ARMS AND ARMOR

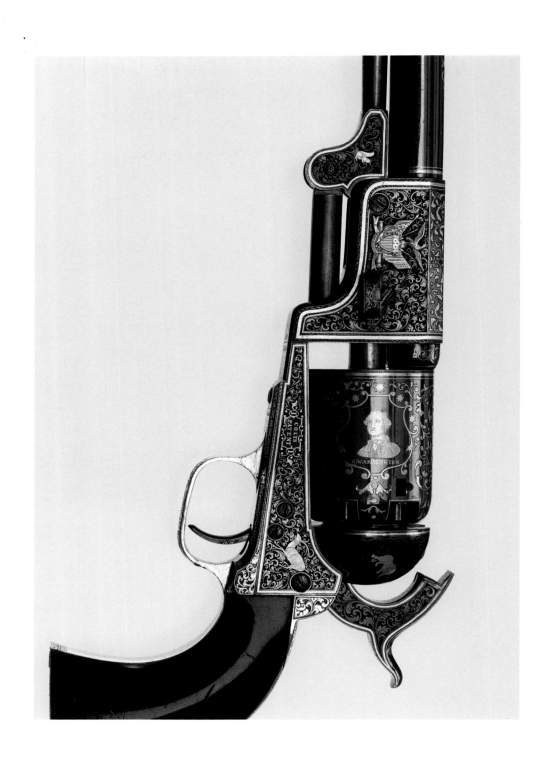

ARMS AND ARMOR

NOTABLE ACQUISITIONS 1991–2002

Stuart W. Pyhrr, Donald J. LaRocca, and Morihiro Ogawa

THE METROPOLITAN MUSEUM OF ART, NEW YORK

YALE UNIVERSITY PRESS, NEW HAVEN AND LONDON

LIST OF DONORS

Donors of Objects or Acquisition Funds
to the Arms and Department since
October 1991

Mr. and Mrs. Prescott R. Andrews Jr.
Annie Laurie Aitken Charitable Lead
 Trust
Mr. and Mrs. Russell B. Aitken
Dean K. Boorman
Lois Earl Blumka
Randolph Bullock
Estate of Nina Elizabeth Bunshaft
Steve and Madeline Condella
Paul and Paulette Cushman
Mr. and Mrs. Edward C. Dittus

Christopher Douglass
George A. Douglass
Jeremy Douglass
Robert Douglass
Edward Coe Embury Jr.
Philip Aymar Embury
The Honorable Peter H. B. Frelinghuysen
Amy Heller
Herbert G. Houze
Royichi Iida
Mr. and Mrs. Robert Andrews Izard
Kenneth and Vivian Lam
Ronald S. Lauder
John K. Lattimer
Ted Lowy

Etsuko O. Morris and John H. Morris Jr.
Morihiro and Sumiko Ogawa
Peter Pruyn
George and Butonne Repaire
Jill Morley Smith
Margarethe Suhl
Arthur Ochs Sulzberger
The Sulzberger Foundation, Inc.
Dorthy Embury Staats
Eric Vaule
John K. Watson Jr.
Mr. and Mrs. Raymond E. Willerford
R. L. Wilson
Estate of Nicholas L. Zabriskie Jr.
Dr. and Mrs. Jerome Zwanger

AUTHORS

Stuart W. Pyhrr, Arthur Ochs Sulzberger
Curator in Charge, Department of Arms
and Armor, The Metropolitan Museum
of Art

Donald J. LaRocca, Curator, Department
of Arms and Armor, The Metropolitan
Museum of Art

Morihiro Ogawa, Senior Research
Associate, Department of Arms and
Armor, The Metropolitan Museum of
Art

CONTENTS

INTRODUCTION

STUART W. PYHRR

This publication and the exhibition it accompanies chronicle more than a decade of collecting by the Department of Arms and Armor at the Metropolitan Museum. Our refurbished galleries in The Pierpont Morgan Wing opened in October 1991 with a new presentation of about eleven hundred of the finest pieces from our encyclopedic collection. Since that time the department's holdings have continued to grow, with more than one hundred and fifty items added by purchase, gift, or bequest. Fifty-eight of the most notable of these appear here. This volume, the first devoted to the Museum's arms and armor acquisitions, also provides us with a welcome opportunity to give recognition and thanks to the many generous donors of objects and purchase funds without whom our collection could not continue to develop.

We especially wish to acknowledge the munificence of Arthur Ochs Sulzberger, Chairman Emeritus of The New York Times Company and former chairman of the Board of Trustees of the Metropolitan Museum. For more than three decades he has also been chairman, and most recently co-chairman, of the Department of Arms and Armor's Visiting Committee, a dedicated group of collectors and friends who provide us with indispensable advice and support. During the 1980s Punch Sulzberger led the fundraising campaign for the refurbishment of the Arms and Armor Galleries. Since then he has endowed the Arthur Ochs Sulzberger Curatorship (the first permanently endowed curatorial chair in this specialized field), underwritten a number of research and conservation projects, and funded the acquisition of many outstanding objects. On January 8, 2002, in recognition of his devoted support and unfailing generosity, the Trustees of the Metropolitan Museum designated the department's special exhibition space the Arthur Ochs Sulzberger Gallery. The exhibition of notable acquisitions, many of which were acquired with Sulzberger funds, is the first display in the newly named gallery. Thus it celebrates not only the continued growth of our collection but also the man most responsible for its development over the last quarter century.

The Department of Arms and Armor oversees more than fourteen thousand objects encompassing material from Europe, North America, the Middle East, India, and much of Asia from about 400 B.C. to A.D. 1900. The collection's broad scope was defined by its first curator, Dr. Bashford Dean (1867–1928), who single-handedly established the department as one of the foremost collections of its kind in the world. In the area of acquisitions Dean was unmatched in his day, or since, in knowing the whereabouts of every important object that was available, or likely to become available, in maintaining close relations with major collectors, scholars, and dealers, in relentlessly pursuing the very best examples of arms and armor, often in the face of intense competition and a chronic shortage of purchase funds. Dean once enumerated the traits essential for the successful collector of arms and armor: an innate passion for the subject, a willingness to study the finest examples throughout the world, a connoisseur's eye, a tenacity of purpose in pursuing great objects, and a large pocketbook. These same traits apply to the museum curator.

Many of the acquisitions included here are remarkable for their diversity and extraordinary quality, condition, and beauty. Some are major items of obvious artistic or historic importance, while others fill gaps or serve as documents, adding to our knowledge of the field. A curator's success in making important acquisitions is affected by a number of variables, including the availability of objects and timely access to them, the level of competition, particularly at public auction, the existence of purchase funds, and the generosity of donors. Coupled with this is a curator's awareness of the history of the Museum's collection, an intimate knowledge of its present holdings, and a vision of the ongoing development of the collection. These factors, and many more, play key roles in determining which objects will be considered necessary or desirable for acquisition. Therefore, in order to see our recent acquisitions in the perspective of the permanent collection, it may be useful to look at the four major areas covered by the Museum's holdings: Europe, North America, the Islamic world, and Asia.

The Museum's section of European arms and armor, numbering about six thousand, is the best known and most extensively published part of its collection. The first significant acquisition was the gift of the John Stoneacre Ellis collection in 1896. The Ellis collection comprised about 150 European armors and weapons, most of them of very modest

quality by today's standards. The Ellis gift, however, may have inspired the Museum's 1904 purchase of the Duc de Dino collection, one of the best private collections of the period. Formed in Paris in the 1880s and 1890s, the collection contained major examples of decorated arms worthy of a great art museum and established the Metropolitan as a serious collector in the field. The appointment of Bashford Dean as honorary curator in 1906, and as full-time curator of the newly created Department of Arms and Armor in 1912, inaugurated an ambitious program of acquisitions, which lasted more than a quarter of a century.

Dean collected unrelentingly for the Museum, acquiring second bests for himself, and encouraged a generation of American collectors. He was instrumental in securing one of the Metropolitan's greatest acquisitions, the collection of almost two thousand examples of European arms and armor formed by William H. Riggs, an American expatriate in Paris, who donated it in its entirety in 1913. Unlike the much smaller Dino collection, which presented arms as objets d'art, the Riggs collection reflected the panorama of military arts, from an infantryman's humble spear to a prince's elaborate harness. The Dino and Riggs collections were thus complementary and established the foundations on which the Museum's collection would grow. The donation of other collections followed, including that of Jean Jacques Reubell in 1926, which consisted of more than two hundred and fifty European daggers and about one hundred smallswords. With Bashford Dean's death the Museum acquired by bequest, gift, and purchase more than one thousand pieces from his outstanding private collection.

Many single items of outstanding quality were purchased by Dean and his successor, Stephen Grancsay (1897–1980). These include some of our best-known and most beloved exhibits, among them the lion-head sallet, ca. 1470, the earliest surviving Renaissance parade helmet; the embossed and damascened armor of King Henry II of France, ca. 1550–55; and the armor garniture of George Clifford, earl of Cumberland, ca. 1580–85, a masterpiece of the English Royal Workshops at Greenwich. The era of the department's great expansion came to an end with the outbreak of World War II, and only in recent decades has a series of important acquisitions been made. Among these are a complete and homogeneous cuirassier armor (cat. no. 14), several exquisitely etched armor elements (cat. nos. 8, 13), and a series of richly embellished weapons (cat. nos. 18, 22, 24, 28), as well as several original designs (cat. nos. 4, 11).

The Museum's small collection of American arms is far from representative of a field that is now the most popular among collectors in the United States. Apparently in Bashford Dean's day neither the utilitarian weapons of the American colonies nor the nineteenth-century machine-made arms were considered essential for display in an art museum. Since World War II, however, research on the history and development of American arms has fostered a great interest in the technical and aesthetic achievements of U.S. arms manufacturers. As a result, this area has become more important for the department in recent years.

The nucleus of the collection of American arms came to the Museum decades ago as gifts. Notable are an extensive series of engraved colonial powder horns, collected by Grenville Gilbert and given by his widow in 1937, and a distinguished group of Colt revolvers, presented between 1955 and 1968 by the pioneer collector John E. Parsons. Since 1991 our American collection has been further enhanced by a few splendid individual donations. Outstanding among these is the gift of the legendary Sultan of Turkey Colt (cat. no. 32), presented by the distinguished dealers George and Butonne Repaire. This gift, among the most important ever made to the department, brought the collection its finest decorated American arm.

The core of the Islamic material in the Department of Arms and Armor comes from three principal sources: a series of fifteenth-century Iranian or Anatolian turban helmets, which were acquired with the Dino collection in 1904; a group of richly jeweled Turkish edged weapons, from the collection of Giovanni P. Morosini, which was presented by his daughter Giulia in 1923; and the wide-ranging collection of some four thousand pieces of armor and weapons assembled by George Cameron Stone, bequeathed to the Museum in 1935.

Long neglected by scholars and curators, Islamic arms have in recent decades attracted considerable attention and are appreciated today as reflections of the Muslim cultures in which they originated. The finest examples are seen as works of art on a par with the textiles, ceramics, metalwork, and painting so long valued by collectors of Islamic art. This heightened appreciation for the subject has coincided with the emergence of a new generation of sophisticated collectors, both in Europe and the Middle East, and has led to the discovery of a number of important early examples of Islamic armor and weapons. We are proud to have acquired in recent years one of the most important Islamic weapons to come on the art market: an early-sixteenth-century Ottoman yataghan, or short sword, from the court of Süleyman the Magnificent (cat. no. 34).

A variety of works from many different periods and cultural regions are grouped under the broadly defined field of Asian

arms. This expansive category has grown in recent years to include a selection of rare and sometimes unique works from Central Asia and Tibet (cat. nos. 41–48). In particular, the unexpected reemergence of Tibetan arms on the art market has prompted the department to acquire select examples to complement and augment the corpus of Tibetan material that came to the Museum with the collection of George Cameron Stone in 1935.

Undoubtedly, the Museum's best-known area of Asian arms is Japanese. Like the European section, the Japanese collection's scope and quality owe a great deal to Bashford Dean. In 1900 and 1905 Dean made extended visits to Japan, where, fascinated by samurai equipment, he formed two collections, primarily in the area of early armor. The first, assembled on the earlier trip, was sold to the Museum in 1904, while the second, formed during his later stay, was donated by him in 1914, after which he ceased collecting in this field.

Dean organized the Museum's first special exhibition of Japanese arms and armor in 1903 and in subsequent years directed the installation of the permanent galleries of Japanese arms and published extensively on the subject. He also encouraged a host of private collectors, many of whom later donated their collections to the department. These included the bequests of Mrs. H. O. Havemeyer (1929) and George Cameron Stone (1935) and the gift of Howard Mansfield (1936), which increased our collection to approximately six thousand examples of armor, swords, decorated sword fittings, and associated accoutrements. Thanks to these benefactors the Museum's collection of Japanese arms and armor is now considered to be the world's most comprehensive outside Japan. In recent years our extensive holdings have been augmented by a few select pieces of outstanding importance, including our earliest dated blade (cat. no. 51) and a complete Edo-period armor with uniquely colored laces (cat. no. 55).

ACKNOWLEDGMENTS

The authors would especially like to thank the donors of works of art and purchase funds who are cited in the List of Donors. Sincere thanks are also due Philippe de Montebello, Director, and the Trustees of The Metropolitan Museum of Art, particularly the members of the Acquisitions Committee, who have regularly encouraged and supported the Department of Arms and Armor in its program of acquisitions.

We would also like to thank our colleagues in the Museum for their assistance and advice while preparing the exhibition and its publication: John O'Neill of the Editorial Department and his staff, particularly Kathleen Howard, Elisa Frohlich, and Robert Weisberg, for creating this handsome publication on short notice; Barbara Bridgers and the staff of the Photographic Studio, especially Oi-Cheong Lee, for providing new photographs for this publication; Patricia Gilkison, Assistant Manager for Gallery Installations; Michael Langley, Exhibit Designer; Zack Zanolli, Lighting Designer; and the staff of the Department of Communications.

In the Department of Arms and Armor we gratefully acknowledge the daily assistance of our coworkers Marilynn Van Dunk and Mari-Anne Spinelli, the administrative staff who helped to prepare the catalogue manuscript and labels, and the conservators who cleaned and mounted the objects, our former colleagues, Joshua Lee and the late Robert M. Carroll, as well as our current staff, Hermes Knauer, Edward Hunter, and Steve Bluto.

Finally, the authors would like to dedicate this publication to the memory of Robert M. Carroll (1946–2000), armorer in our department for more than three decades, whose consummate skill as a conservator greatly improved the appearance of many of the acquisitions included here. Indeed, we depended on his many years of experience and his expert knowledge of antique arms, particularly of materials and techniques, when reviewing objects for acquisition. Many purchases were made—and others avoided—thanks to his sharp eye, sound judgment, and keen enthusiasm.

EUROPE

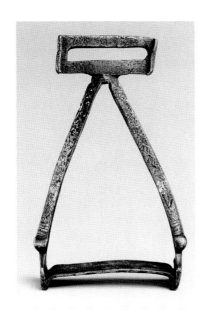

1. Viking Stirrup

Northern European or Scandinavian,
9th to 11th century
Iron, silver, and copper
H. 7 in. (17.8 cm); w. 4⅛ in. (10.3 cm)
Purchase, Arthur Ochs Sulzberger Gift, 1999
(1999.159)

The advent of stirrups, particularly metal ones, significantly changed the way in which horses could be used, especially in warfare. The earliest forms were simple leather slings, toe stirrups (consisting of a ring for only the big toe), and stirrups made of leather with a wooden footrest. The first evidence for the existence of true metal stirrups comes from China, where they may have been invented and where they were known from at least as early as the fifth century. Metal stirrups spread through Central Asia and then reached Eastern Europe by perhaps the sixth century and Northern and Western Europe during the seventh and eighth centuries.

The Museum's stirrup dates from the height of the Viking era and is among the earliest forms known to have been used in Northern Europe and Scandinavia. Distinguishing features of this type include the broad rectangular slot for the stirrup leather and the steep triangular arch for the rider's foot. It was decorated over much of its surface with inlaid wires of copper and silver forming repeating geometric patterns, which are now very worn due to corrosion. Although used mostly in the North and in England, stirrups of this type have been found as far afield as southwestern France, eastern Germany, and Switzerland.

In addition to this stirrup, Viking-related arms in the Museum include a very fine sword (55.46.1), inlaid with silver and copper; a stirrup (47.100.23) also elaborately inlaid in copper, of the type associated with Viking finds in Denmark and England; and a group of arms and accoutrements (46.79.1–11) excavated from a warrior's grave and donated by the Universitets Oldsaksamling Oslo as a token of appreciation for U.S. assistance to Norway during World War II. D J L

2. Vambrace for the Left Arm

Italian (probably Milan), ca. 1510–20
Steel and leather
L. 24 in. (61 cm)
Rogers Fund, 2000 (2000.268)

Ex coll.: [Samuel L. Pratt, London]; Marquis of Breadalbane, Taymouth Castle, Perthshire, Scotland; [Peter Dale Ltd., London]; Ian Eaves, London.
Ref.: Anonymous [Pratt] sale 1861, lot 253.

The last years of the fifteenth century and the first decades of the sixteenth,

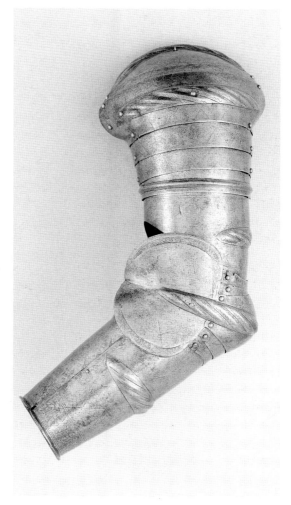

roughly corresponding to the so-called Italian Wars (1494–1529) that brought French and imperial armies onto the Italian battlefields, constitute an especially fascinating period of development in European armor. This international exposure and inevitable cultural exchange led to a gradual transformation of armor design, including the adoption in Germany of the broader, more robust, and rounded forms of Italian armor and the more limited acceptance in Italy of the German preference for decoratively ribbed and fluted surfaces. Though relatively few complete Italian armors of this period survive, even single elements such as this arm defense, or vambrace, offer testimony to the innovations of these years.

The vambrace is constructed of fourteen plates connected by rivets and internal leather straps so as to maximize flexibility. The shallow caplike shoulder defense, or spaudler, is of German type and indicates that the armor to which this vambrace belonged was intended for light cavalry or infantry service. The articulation of the upper vambrace to the pauldrons (shoulder defenses) by means of a turning joint and of the elbow, or couter, directly to the arm defenses above and below, are typically Italian features that were also adopted by German armorers.

It is the decoration, however, that distinguishes this vambrace from others of the period. The raised and roped transverse ridges on the top of the shoulder and elbow and across the upper and lower arm defenses are highly unusual and give it a bold and powerful form unrelated to defensive needs. The surfaces also retain traces of a shallow linear etched ornament typical of Italian armor of this period but here employed in a truly original pattern. Bands of conventional foliage on a diagonal hatched background follow the main edges, while the remaining surfaces are covered with a crisscross diaper pattern, the resulting lozenges alternately crosshatched or left plain, like an overall checkerboard. It is

no wonder then that, when catalogued for sale in 1861, this decoration was interpreted as a plaid pattern and the vambrace was naively identified as a "Scotch arm." Perhaps for that reason it was acquired for the great Gothic Revival armory assembled by the earl of Breadalbane, Taymouth Castle, Perthshire, where it was discovered several decades ago after having been forgotten in an old tea chest on the property.

S W P

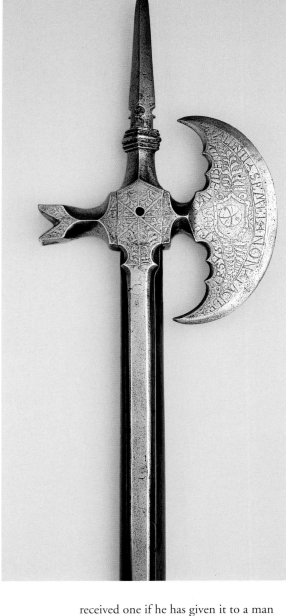

3. Horseman's Ax

Italian, ca. 1532
Steel, gold, and wood
L. (overall) 30¾ in. (78.1 cm)
Purchase, Ronald S. Lauder
and The Sulzberger
Foundation Inc. Gifts, 1993
(1993.61)

Ex coll.: Medici armory,
Florence, until ca. 1775; [Hal
Furmage, London]; Gerald
Wiedman, Rickmansworth,
England; [Ralph Parr,
Lancaster, England]
Ref.: Pyhrr 1993, pp. 30–31, ill.

This elegantly proportioned and delicately ornamented ax probably served more as a symbol of authority than as a weapon for mounted warfare. The surfaces are etched and gilt with foliage on an obliquely hatched ground, in the manner of early-Italian ornamental prints. The ax blade is further decorated on one side with a shield enclosing the Medici arms and a Latin inscription around the edges BENIFICIVM · DANDO · ACCEPIT · QVI · DIGNO · DEDIT (He who confers a benefit has

received one if he has given it to a man worthy of it), and on the other side with the device of an inflatable soccerlike ball and the inscription FALLENTI · SEMEL · NON · FACILE · RVRSVS · FID(E)S · ADHIBENDA · EST · (Trust is not again to be placed easily in those who have once deceived). Although the inflatable ball was used as a personal badge by several members of the Medici family, here it most likely refers to Cardinal Ippolito de' Medici (1511–1535), a youthful prelate

more at home in armor than his scarlet robes of office. In 1532 Ippolito commanded an expedition against the Turks in Hungary, an event immortalized in Titian's portrait in the Uffizi, Florence, in which the cardinal wears the exotic costume of a Hungarian soldier. This ax very likely accompanied Ippolito on that campaign.

For almost two centuries a large armory occupied a suite of galleries on the upper floor of the Uffizi, where the dynastic collections of the Medici rulers of Florence were displayed. The armory was seen by a steady stream of local and foreign visitors who marveled at harnesses worn by famous men, curious weapons of earlier times, and richly jeweled arms from the Orient. The Museum's ax undoubtedly entered the armory as a memento of Ippolito following his death, but it is only clearly identifiable in an inventory of the Medici armory in Florence in 1695, where it is described as having a wooden haft studded with brass nails with rosette heads. The present haft is a modern replacement. In 1775, when the Medici collections were reorganized, a large portion of the armory was sold. The dispersal scattered the contents far and wide, but more than a half dozen of these arms have entered the Metropolitan's collection including, most recently, this ax and two other items discussed below (cat. nos. 9 and 10).

SWP

4. Design for a Sword Hilt

German (probably Nuremberg), ca. 1540
Pen, ink, and wash on paper
8½ x 11⅜ in. (21.5 x 29 cm)
Rogers Fund, 2000 (2000.27)

Ref.: Pyhrr 2000, p. 25, ill.

Original designs for Renaissance swords are exceptionally rare, although notable examples by such renowned artists as Hans Holbein the Younger and Giulio Romano are preserved. Previously unrecorded, the present drawing is a significant addition to this small corpus and is a work of art in its own right. The style and iconography point to Nuremberg and possibly to Peter Flötner (ca. 1486–1546), one of that city's most versatile artists. Of robust proportions, the hilt was presumably intended as a side arm to be executed in chased silver or gold. The pommel is conceived in the round with four female heads beneath an imperial crown, while the grip is embellished with a double-headed imperial eagle incorporated into a classical trophy of arms. The guard, formed of undulating branches of acanthus leaves and scrolls, is asymmetrical, one quillon ending in a shield-bearing demi-lion and the other in a Janus head. A lion's head at the intersection of the quillons anchors the composition.

The design is novel and has strong Italianate features, hallmarks of Flötner's oeuvre. The trophies in particular recall one of the artist's woodcut designs for a dagger grip. The distinctive crowned pommel, on the other hand, is virtually identical to one in the design for a sword of Emperor Charles V that is dated 1544 and ascribed to the celebrated Nuremberg goldsmith Wenzel Jamnitzer (1508–1585). The present drawing, however, reflects none of the Mannerist aesthetic of Jamnitzer's art and is clearly by a different hand and probably of slightly earlier date. The presence of the imperial iconography, on the other hand, suggests that it too was created for Charles V. SWP

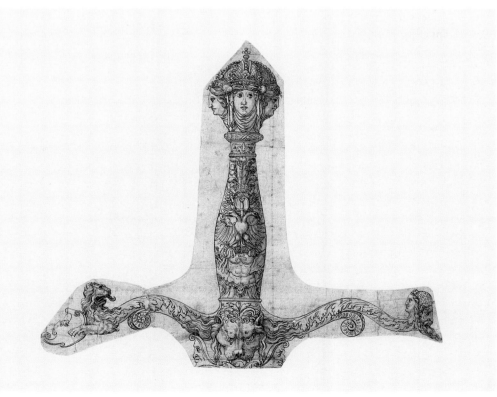

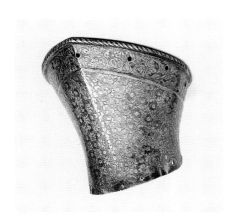

5. Cuff for the Left Gauntlet Belonging to an Armor of Francis II of France

French, ca. 1555–60
Gilt steel
L. 5¼ in. (14.6 cm)
Purchase, Bashford Dean Memorial Collection,
Funds from various donors, by exchange, 1993
(1993.74.1)

Ex coll.: F. A. de Leeuw, Düsseldorf; Hans C.
Leiden, Cologne; William Randolph Hearst, Saint
Donat's Castle, Wales; Raymond Bartel
Ref.: Leiden sale 1934, lot 41; Anonymous
[Bartel] sale 1954, lot 103.

Detached elements of armor are valued by specialists not only for their individual aesthetic merits but also for the evidence they provide as to the original appearance and composition of an armor. This gauntlet cuff and the following two items (cat. nos. 6 and 7), while attractive to the connoisseur's eye, contribute important documentation for three rare French Renaissance harnesses, two of them of royal provenance.

Discovered in a private collection, the gauntlet cuff was acquired by the Museum as a modestly priced curatorial purchase so as to prevent its future disappearance in the art market. Etched and gilt with an allover diaper pattern, the intersecting lines punctuated with a stylized flower, this fragment is readily identifiable as matching an armor of King Francis II of France (1544–1560), who ruled briefly from July 1559 following the tragic death

of his father, Henry II, in a joust. The brilliantly gilt harness (fig. 1) includes a close helmet, a breastplate with holes for a lance rest, and a right pauldron (shoulder defense) shaped at the front to accommodate a couched lance, features that are characteristic of a traditional field armor. The customary leg defenses are now missing. The Paris armor possesses two gauntlets and therefore would seem not to need a third. Upon closer inspection, however, the left gauntlet now mounted with the harness is in fact one for the right hand and is constructed as a special locking gauntlet— one in which a sword could be secured without danger of loss—for use in the tourney, a mock combat fought by opposing troupes of knights. The discovery of the gauntlet cuff now in the Metropolitan not only helps to complete this royal armor but also allows us to identify it as one intended for both field and tourney use. One can imagine the armor having been made for the teenage prince, perhaps shortly before his accession, to show off his martial skills in a royal tournament. S W P

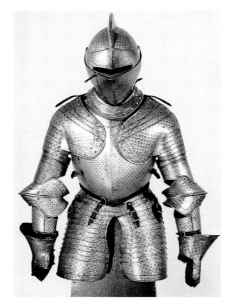

Fig. 1. Armor of Francis II, Musée de l'Armée, Paris (G.119)

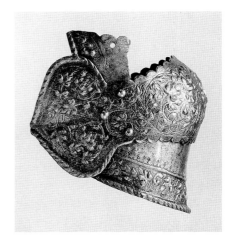

6. Right Knee Defense for an Armor of Claude Gouffier

French (probably Paris), ca. 1555–60
Steel, gold, and brass
H. 6¼ in. (15.9 cm)
Gift of Mr. and Mrs. Prescott R. Andrews Jr.,
1994 (1994.390)

Ex coll.: [Sumner Healey, New York]; Stephen V.
Grancsay, Brooklyn
Ref.: Allentown 1964, p. 44, no. 68, ill.; Écouen
1994, p. 107; Pyhrr 1995, pp. 32–33, ill.

This is the only known fragment from what once must have been a magnificent French parade armor. The knee (or poleyn) consists of a main plate covering the kneecap with a heart-shaped wing on the outer side, with a portion of the lame above and a deep downward-overlapping lame below. This last has a turned and boldly roped lower edge, suggesting that it was the terminal lame of a long articulated tasset that extended from the waist to the knee, a type with which no lower leg defenses were worn. Armor so constructed followed Italian prototypes and was typically worn by the light cavalry. Its embossed and gilt decoration, consisting of dense foliate scrollwork and a grotesque mask with ram's horns (fig. 2) at the front of the main plate, recalls the ornamental motifs and workmanship of the Museum's armor of Henry II of France (39.121), which was probably made in a Parisian atelier about 1555. Etched on the

plate below the knee is the gilt monogram formed of the Greek letters chi and phi that identifies it as having belonged to the distinguished courtier, soldier, and patron of the arts Claude Gouffier (1510–1570), *grand écuyer* (master of the horse) of France. The same monogram, which incorporates the initials of Claude and his second wife, Françoise de Brosse, is found everywhere in the decoration of Gouffier's château of Oiron (Deux-Sèvres) and on the numerous bookbindings and manuscript illuminations commissioned by this ardent bibliophile. It recurs on another piece of armor, a richly etched and gilt French close helmet of similar date, which by happy coincidence is also in the Metropolitan's collection (14.25.596).

s w p

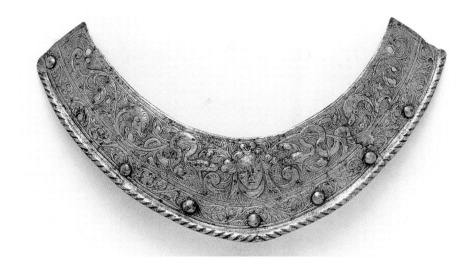

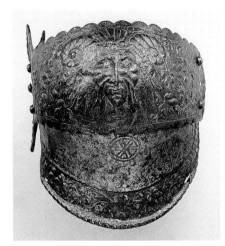

Fig. 2. Mask and monogram (front view of cat. no. 6)

7. Collar Plate for a Helmet of Henry III of France

French, probably Paris, ca. 1570
Steel
10¼ x 6 in. (25.9 x 15 cm)
Gift of Prescott R. Andrews Jr., 1999 (1999.448)

Ex coll.: Prince Radziwill, Nieświcż Castle, Lithuania; Stephen V. Grancsay, Brooklyn
Ref.: Allentown 1964, pp. 44–45, no. 69, ill.; Thomas 1965, pp. 84–86, fig. 113; Pyhrr 2000, p. 25, ill.

This single plate served as the lowermost front collar lame of a French close-helmet embossed in low relief with grotesque ornament in the style of the Parisian goldsmith–engraver Étienne Delaune (1518/19–1583). The helmet (fig. 3), now lacking its collar, originally formed part of a parade armor made for the future Henry III of France (1551–1589, ruled from 1574). The appearance of the harness is recorded in a contemporary portrait drawing of the young prince in the Bibliothèque Nationale, Paris, which shows a half-length armor covered with foliate scrolls inhabited by allegorical figures, lions, snakes, and fantastic beasts. Prior to ascending the French throne, Henry ruled briefly as king of Poland (1572–74), where he appears to have left behind this splendid armor, perhaps mak-

ing a gift of it to one of his courtiers. The Museum's collar plate and presumably the Paris helmet were formerly preserved in the armory of the powerful Polish magnates, the Radziwill, in their castle at Nieświcż in Lithuania. The collar lame was presented in 1927 by Prince Albrecht Radziwill to Stephen V. Grancsay, then the Metropolitan's assistant curator of Arms and Armor, in recognition of the young curator's assistance in rearranging what remained of the family's ancient armory.

s w p

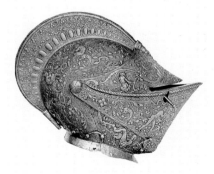

Fig. 3. Helmet of Henry III. Musée de l'Armée, Paris (H.259)

8. Morion

German (Brunswick), ca. 1560–65
Etched steel
H. 12½ in. (31.8 cm)
Purchase, The Sulzberger Foundation Inc. and Ronald S. Lauder Gifts, 1999 (1999.62)

Ex coll.: [B. Kurtz, Vienna]; Stephen V. Grancsay, Brooklyn; John F. Hayward, London; David G. Alexander, Puycelsi, France
Ref.: New York 1931, p. 29, no. 90, ill.; Allentown 1964, p. 40, no. 59; Hayward sale 1983, lot 26, ill.; Pyhrr 1999, p. 28, ill.; Pyhrr 2000b, p. 31, ill.

This helmet is an outstanding example of parade armor made in northern Germany for the court of the dukes of Brunswick. Apart from Augsburg and Nuremberg, the principal armor manufacturing centers located in the south, numerous smaller urban and court workshops existed throughout German lands, few of which have been studied. One of the most distinctive and original of these produced parade armors for Duke Heinrich the Younger of Brunswick-Wolfenbüttel (r. 1514–68) and his son Julius (r. 1568–89). Characteristic of the "Brunswick" school (the exact location of the workshop has not been identified) is the predominance of finely rendered figural decoration, with subjects drawn from ancient history, mythology, and the Bible. The etching of this morion is exceptionally accomplished and includes, on the sides of the bowl, vigorously rendered equestrian warriors in classical armor and, on the tall comb, medallions enclosing busts of Alexander the Great (fig. 4) and Antonia Sabina Augusta, wife of the Roman emperor Hadrian. The classical subjects, complex design, and horror vacui typify the northern Mannerist aesthetic.

The association of this morion with the Brunswick court is underscored by the similarity of the strapwork border around the edge of the brim with ornament found on the armor of Duke Julius,

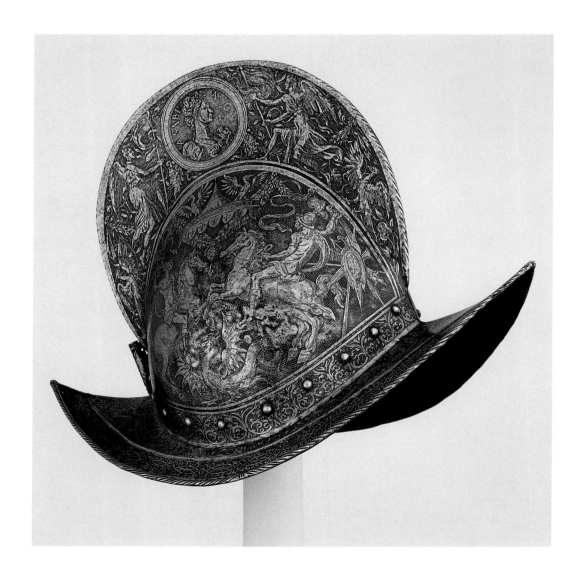

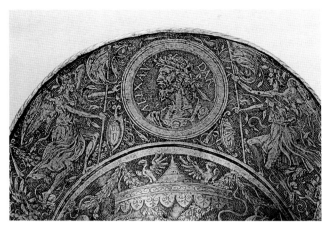

Fig. 4. Bust of Alexander the Great

dated 1563, in Windsor Castle. If contemporary, the Museum's morion would be an early example of two-part helmet construction, in which the bowl is formed in halves joined along the comb, which became commonplace throughout Europe toward the end of the century.

The decoration on the left side of the comb includes a shield emblazoned with three small shields, the arms of the guild of Saint Luke, the painter's guild to which many etchers belonged. This detail suggests the possibility that the morion was created as a "masterpiece" submitted by an etcher in order to become a recognized master in his art. This would explain the self-conscious virtuosity of the etching and the unusual combination of motifs.

SWP

9. Hunting Sword

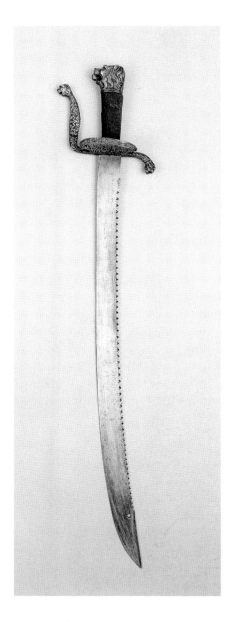

Swiss, ca. 1580
Steel, iron, wood, and fish skin
L. (overall) 32¼ in. (82 cm)
Purchase, Jerome Zwanger, Ronald S. Lauder,
Mr. and Mrs. Russell B. Aitken, George A.
Douglass, John K. Lattimer, John K. Watson Jr.,
and R. L. Wilson Gifts, 1994 (1994.206)

Ex coll.: Medici armory, Florence, until ca. 1775;
Counts Erbach-Erbach, Schloss Erbach,
Odenwald, near Darmstadt
Ref.: Demmin 1869, p. 409, fig. 76; Müller-
Hickler 1926, pls. 26, 27; Anonymous sale 1993,
lot 8104, ill.; Pyhrr 1994, p. 29, ill.

Though not at first glance a princely side arm, this rugged hunting sword comes from the Medici armory in Florence and is described in detail in inventories dating from 1589 until the dispersal of the armory in 1775. It reappeared in Germany about 1785, at Erbach Castle near Darmstadt, where it formed part of one of the earliest Gothic Revival armories.

The distinctive pommel, formed as a lion's head with a long separately inserted tongue, is of the type commonly found on Swiss sabers of the late sixteenth century. The deeply chiseled iron guard, with its Renaissance foliage and grotesques, is unusually elaborate for a Swiss weapon and indicates that the sword was created for someone of high rank. The fish skin

covering the wooden grip, a form of waterproofing, and the heavy sawback blade suggest that it was intended for practical use. In fact, the earliest record of the sword, in 1589, when it was in the private wardrobe of Grand Duke Ferdinand I de' Medici (1549–1609, ruled from 1587) in the Palazzo Pitti, describes it as having a leather-covered scabbard fitted with a compartment containing five utensils or tools of the type that might be useful to a hunter in the field.

SWP

10. Combination Ax-Pistol of Grand Duke Ferdinand I de' Medici

German, ca. 1580
Steel, parcel gilt
L. 27¾ in. (70.5 cm)
Purchase, Arthur Ochs Sulzberger Gift, 2002
(2002.174a, b)

Ex coll.: Medici armory, Florence, until ca. 1775;
[S. J. Whawell, London]; [Herb Ratner Jr.];
[Joseph Kindig Jr., York, Penn.]; [Joseph Kindig III, York]
Ref.: Frost 1972, p. 184, fig. 291.

The invention of the wheel lock in the early sixteenth century established a fairly reliable, if complex and expensive, firearms ignition system that engendered the rapid development of pistols and long arms for both warfare and the hunt. By the middle of the century a new genre of weapon developed, combining a wheel-lock pistol and a conventional sword, dagger, ax, or mace. This would seem to imply a basic insecurity on the part of the owner, suggesting that if his shot missed he could rely on the weapon's second function as a backup. In reality, however, combination weapons of this sort appealed to the wealthy nobleman as elaborate mechanical curiosities, and they are found in abundance in the princely armories and Renaissance *Kunst- und Wunderkammern.*

This ax-pistol, like most recorded examples, is of German manufacture and follows conventional all-steel construction in which the hollow shaft of the ax serves as the pistol barrel, with the lock (modern replacement) attached to the outer side; the shaft is pierced with a touchhole and fitted with a trigger. The grip, which is framed by a molding at either end, terminates in a hollow pommel formed of two hinged halves that probably served as a storage compartment for pyrites, wadding, bullets, or even ancillary tools. The forward end of the shaft is fitted with an S-shaped ax blade and a curved spike or fluke behind it; the barrel opening is closed with a baluster-shaped plug that would be removed before the pistol was fired. The surfaces of the ax, shaft, and bottom half of the pommel are etched with strapwork interlace and scrollwork on a blackened ground, highlighted by areas of gilt foliage, in the South German style employed in Augsburg and Nuremberg. Each face of the ax is etched in the center with a cartouche, that on the outer (lock) side encloses the Medici arms surmounted by a rayed crown (fig. 5), while that on the inner side encloses the profile head of a helmeted warrior.

The presence of the Medici arms indicates that this weapon was made after December 1569, when Cosimo I de' Medici (1519–1574, ruled from 1537) was elevated from duke of Florence to grand duke of Tuscany, and a new crown of rayed type was adopted. The owner of the weapon appears not to have been Cosimo himself but his second son,

Fig. 5. Medici arms surmounted by a rayed crown

Cardinal Ferdinand (1549–1609), who ruled from 1587. The ax-pistol is first recorded in the Medici archives in 1589, when it was in Ferdinand's private armory (*armeria secreta*) in his residence at the Palazzo Pitti, Florence. There it was clearly described, including the grip, which is now plain, as having been covered in black velvet with fringe of black silk and gold. The entire weapon was stored in a case of black leather furnished with black velvet cords and tassels of black silk and gold. S W P

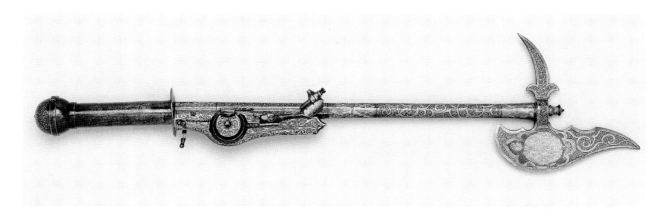

11. Design for a Saddle Plate

Italian (Parma or Milan), ca. 1575–80
Pen and colored washes on paper, 19½ x 16⅛ in.
(49 x 39.2 cm)
Purchase, Fletcher Fund and Gift of William H.
Riggs, by exchange, 1993 (1993.234)

Ref.: LaRocca 1994, p. 23, ill.

This preparatory drawing depicts the front saddle steel of one of the most lavishly decorated armor garnitures of the sixteenth century, made for Alessandro Farnese (1545–1592), duke of Parma and Piacenza. The complete armor for man and horse is in the Hofjagd- und Rüstkammer (Court Hunting Cabinet and Armory) of the Kunsthistorisches Museum, Vienna. It was made by the Milanese armorer and goldsmith Lucio Piccinino about 1575–80.

The exuberantly detailed Mannerist ornament represented in the lifesize drawing was rendered on the armor by low-relief embossing, with the principal figures silvered, the ornamental enframements gilt, damascened in gold, and the background blued to create an overall spatial and coloristic effect of amazing richness. Other designs for the various parts of the Farnese armor, of which this drawing is among the finest, are now dispersed among public and private collections in the United States and Europe. Preparatory drawings for armor are exceptionally rare. The only examples comparable to the Farnese group in scope and quality are the sketches by Albrecht Dürer for a silvered armor commissioned by Emperor Maximilian I in about 1515, and an extensive series by Étienne Delaune and other court artists made for the Valois kings of France between 1545 and 1570.

DJL

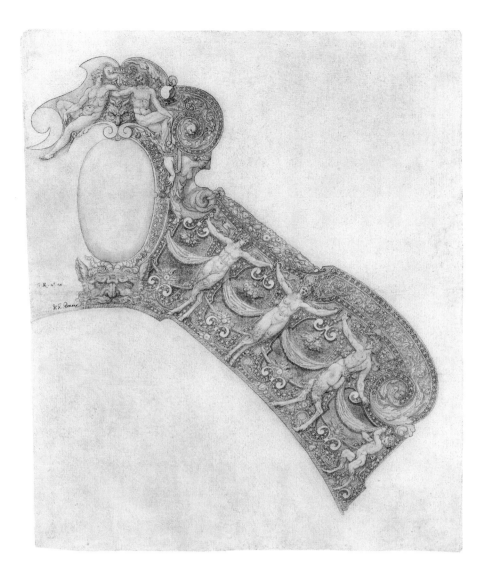

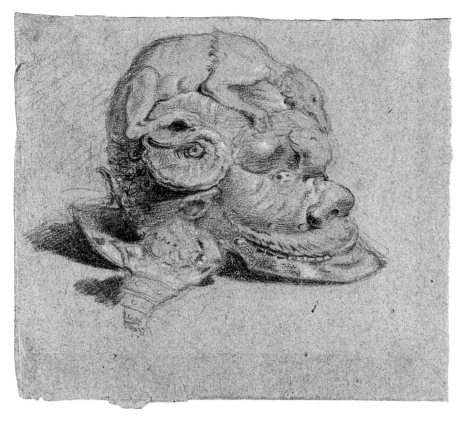

12. Drawing of a Parade Helmet

*Italian (probably Venice), second half of the
sixteenth century*
Colored chalk on blue paper
7½ x 8¼ in. (19 x 21 cm)
Purchase, Bernice and Jerome Zwanger Gift, 1997
(1997.6)

Ex coll.: J. David Wille
Ref.: Pyhrr and Godoy 1998, p. 326, no. 66, ills.

Unlike the previous example, which is an
original preparatory design intended to
guide the goldsmith-embosser in decorat-
ing an armor, this drawing renders the like-
ness of a helmet already in existence. It
undoubtedly records an example seen in
a private aristocratic armory and is prob-
ably a study for use by the artist in a por-
trait of its owner, in which, following
conventions of the time, the helmet of
the armored sitter was not worn but rested
on a nearby table or ledge. The assured
draftsmanship and delicate coloring attest

to the skill of the artist, who may have
been Venetian but otherwise remains
unidentified. Beyond its visual appeal,
the drawing is important as a record of an
Italian Renaissance parade helmet
embossed in high relief in the classiciz-
ing manner of Filippo Negroli of Milan.
The helmet, which is probably a Milanese
work of about 1540–50, still survives and is
in the State Hermitage Museum, Saint
Petersburg (z.o. 6160). The helmet today
lacks its hinged cheekpieces, one of which
is carefully documented in this drawing.

SWP

POMPEO DELLA CESA
ITALIAN, ACTIVE CA. 1565–1600

13. Portions of an Armor for Vincenzo Luigi di Capua, Prince of Riccia

Milan, ca. 1595
Steel, gold, leather, and brass
H. 19 in. (48 cm)
Purchase, Arthur Ochs Sulzberger Gift, 2001
(2001.72)

Ex coll.: David G. Alexander, Puycelsi, France
Ref.: LaRocca 1993; Pyhrr 2001, p. 27, ill.

Italian armor making in the last quarter
of the sixteenth century was dominated
by Pompeo della Cesa, armorer to the
Spanish court in Milan. His richly deco-
rated harnesses were commissioned by
Philip II of Spain, the ruling dukes of
Savoy, Parma, and Mantua, and the
scions of the leading Spanish and Italian
families. Pompeo was one of the few
armorers who regularly signed his pieces,
a reflection of his pride of workmanship
and his elevated status in the world of
military *alta moda*.

Pompeo's prodigious output includes
more than three dozen armors bearing
his signature, the largest surviving corpus
of work by any Italian armorer. Only
recently discovered and published, the
Metropolitan's armor is a significant
addition to Pompeo's oeuvre and intro-
duces us to a new and important patron
of the armorer's art. Vincenzo Luigi di
Capua (d. 1627), prince of Riccia and
count of Altavilla, belonged to an ancient
Neapolitan family. Don Vincenzo's armor,
presumably made shortly after he suc-
ceeded to his noble titles in 1594, exempli-
fies Pompeo's best work. The surfaces are
covered with closely set vertical bands
etched and gilt with grotesques, trophies of
arms, and religious and allegorical figures.
The owner's emblem, or impresa, appears
at the top of the breastplate—a radiant
sun with a crown above and a motto
below, NVLLA QVIES ALIBI (No repose

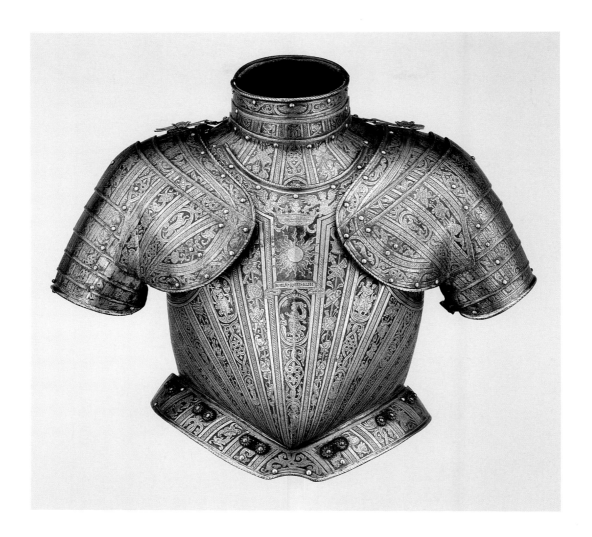

but here); the armorer's name, P O M P E O, is etched beneath (fig. 6). Now incomplete, the half-length infantry armor originally included an open-faced helmet, arm defenses, gauntlets, and tassets (upper thigh defenses); the matching backplate is preserved in the armory at Warwick Castle, England. Two additional armors made for Don Vincenzo are also at Warwick, including a second, elaborately decorated harness by Pompeo.

Prior to the acquisition of the present armor, the Museum possessed two unpublished examples by Pompeo: portions of an armor for field and tournament use, ca. 1570–75 (14.25.812a; 14.25.818; 29.158.534a), and elements of a child's armor, ca. 1580 (14.25.704), both in poor condition. The di Capua armor thus fills an important gap, providing us at last with a well-preserved, first-rate example by Milan's leading armorer. S W P

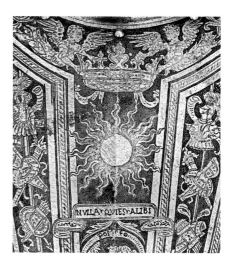

Fig. 6. Impresa, motto, and armorer's name (Pompeo)

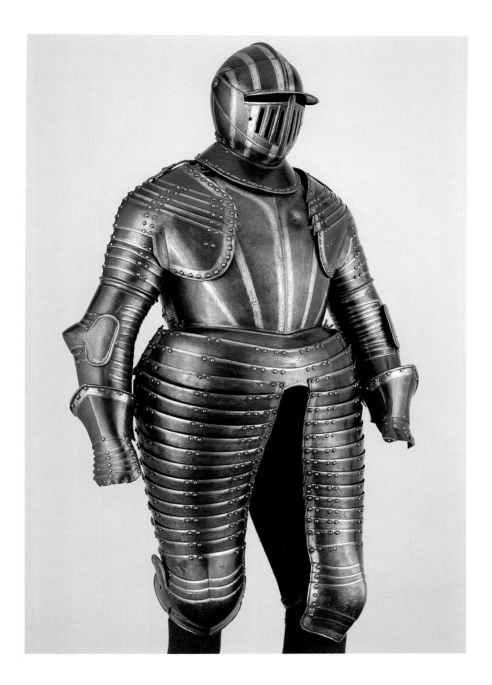

14. Cuirassier Armor

Italian (Milan or Brescia), ca. 1610–20
Steel, gold, leather, and textile
H. as mounted, 54 in. (137.2 cm); wt. 86 lbs. 8 oz.
(39.2 kg)
Purchase, Arthur Ochs Sulzberger Gift, 2002
(2002.130a–p)

The construction and build of this armor are typical of a cuirassier's harness, a new type that evolved toward the end of the sixteenth century in response to changing military tactics and the increasing use and efficiency of firearms, and that remained in use well into the seventeenth century. The cuirassier, or heavy cavalryman, wore a three-quarter length armor that included a close helmet and knee-length tassets; the lower leg defenses of plate worn in earlier eras had been replaced by high boots. The lance, the traditional weapon of the mounted knight since the Middle Ages, was abandoned in favor of pistols contained in holsters at the front of the saddle. The cuirassier typically charged the enemy, fired his weapons at close range, and then retreated to reload. This change in weaponry led to an evolution in the appearance of armor: the lance rest fitted on the right side of the breastplate was no longer necessary, and the right pauldron, usually of smaller size at the front to allow the couching of the lance beneath

the arm, became symmetrical with the left one. The closed vambraces, with the bend of the elbow protected by a series of overlapping narrow lames, are also typical of this kind of armor.

The deadly force of pistols fired at close range caused the armorer first to increase the thickness and weight of his plates and then to supplement them with reinforces to double the protection. Armor was also tested to be shot-proof by means of firing at it at prescribed ranges, with the bullet dents left visible as an armorer's guarantee of the strength and quality of his product. The present armor retains two reinforces—a rarely encountered plate for the back of the helmet bowl and a placard for the breastplate—and it formerly possessed a third one for the front of the visor. Weighing more than eighty-six pounds, it is one of the heaviest field armors known. The breastplate, backplate, helmet reinforce and placard of this armor exhibit such proof marks. Although generally conforming to the construction of cuirassier harnesses worn in Europe ca. 1600–1640, this example is typical of northern Italian (Milan or Brescia) workmanship. Particularly characteristic are the form of helmet, with a pivoted peak over the eyes and a slotted visor, and the simple decoration of incised and brightly polished bands contrasting with the blued steel surfaces. Sturdy and well made, the armor has been endowed with graceful lines and good proportions in addition to the more practical considerations of defense.

The Museum's acquisition of this armor allows us to tell a more complete and vivid story than was previously possible about the evolution of European armor in the age of firearms. The armor's immense weight, its reinforcing plates, and the deep proof marks provide a vivid reminder of the armorer's constant struggle to adapt his product to changes in tactics and weaponry as well as in fashion.

S W P

15. Parade Helmet à l'Antique

French, probably Paris, ca. 1620–30
Steel, brass, paint, and textile
H. 14⅞ in. (37.6 cm)
Purchase, Gift of William H. Riggs, by exchange, 1997 (1997.341)

Ref.: Pyhrr 1998, pp. 28–29, ill.

A reflection of the classical tradition in early Baroque France, this parade helmet with its distinctive arched comb was intended to evoke the armor of ancient Rome. The comb is pierced with pairs of lacing holes by which an elaborate feathered plume would have been attached. The colorful effect was further enhanced by the presence on the helmet of numerous brass rivet heads and by the use of gold paint to highlight the incised foliate scrolls on the sides of the bowl, the raised shell-like motifs, and the bands along the edges. The padded lining, remarkably still intact, was originally covered with salmon-pink silk. Undoubtedly created for a member of the French court of Louis XIII (r. 1610–43), the helmet was probably intended for use in a pageant, ceremonial entry, or *carrousel à l'antique*. Helmets of nearly identical design, certainly from the same workshop, are in the Musée de l'Armée, Paris (H.169), and in the Wallace Collection, London (AIII). The acquisition of this helmet significantly strengthens the Museum's superb holdings of French armor and complements in particular the Metropolitan's distinguished group of firearms coming from the personal *cabinet d'armes* of Louis XIII.

S W P

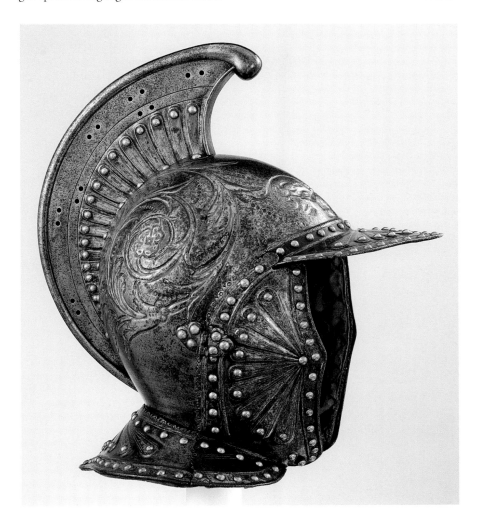

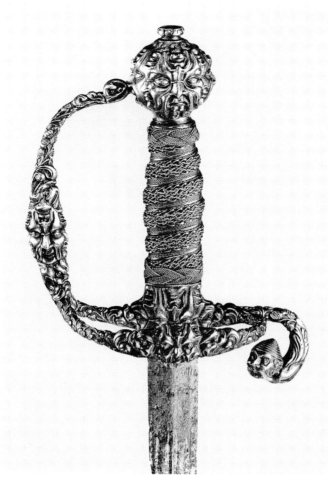

The chiseled iron hilt, formerly gilt, was undoubtedly made for an aristocrat or wealthy burgher and displays an unexpected but delightful whimsy in its decoration. The pommel and guard are composed of fleshy faces combining frontal and profile views that are symmetrical when viewed with the blade pointed up or down. The long rear quillon is unusual, ending in a head of an exotic man with a flowing mustache and wearing a curious stepped conical hat. The decoration is rooted in the Mannerist love of grotesques and fantastic human forms, playful motifs that continued to be popular in Germany and the Netherlands well into the seventeenth century. Two hilts with similar chiseling from the armory of the Swedish general Carl Gustav Wrangel (1613–1676) at Skokloster Castle are described in an inventory of 1651 as Dutch, suggesting the probable date and origin of the present hilt. The blade is stamped with the bishop's-head mark of the renowned Solingen bladesmith Peter Munich (recorded ca. 1610–50).

When acquired, this sword lacked its grip. The present one, formed of fourteen alternating strands of braided, twisted, and plain copper wire or ribbon over a wooden core, was masterfully fabricated by the Museum's armorer, the late Robert M. Carroll, who copied the genuine grip on a contemporary Dutch rapier in the Metropolitan's collection. SWP

16. Rapier

Probably Dutch, ca. 1650
Iron and steel; modern grip of wood and copper
L. 36 in. (91.5 cm)
Purchase, Bashford Dean Memorial Collection,
Funds from various donors, by exchange, 1995
(1995.51)

Ex coll.: Counts Erbach-Erbach, Schloss Erbach,
Odenwald, near Darmstadt
Ref.: Pyhrr 1995, p. 36, ill.; LaRocca 1998b, p. 31,
ill.

During the second quarter of the seventeenth century a new form of civilian side arm came to be worn in western Europe that was shorter, lighter, and with a more compact hilt than the more robust "swept hilt" rapiers carried since the mid-sixteenth century. The present rapier reflects this transition in its reduced size and simpler construction.

17. Smallsword

Sri Lankan (Ceylon, for the European market),
ca. 1700–1725
Brass, steel, and wood
L. 37½ in. (95.3 cm)
Purchase, Arthur Ochs Sulzberger Gift, 2000
(2000.488)

This is an extremely rare example of a European-style smallsword made in Sri Lanka (formerly Ceylon) for export to the West via the Dutch East India Company. The decoration, consisting of minute

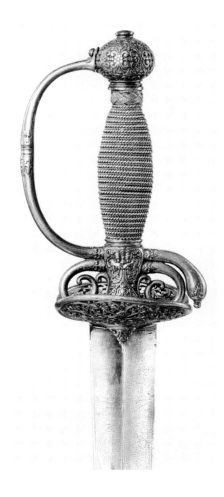

foliate scrolls, cusped leafy collars, and demon mask, is typically Sinhalese. The style of hilt, with its "baggy" quillon block, thick quillon, and moldings around the shells, suggests a European model dating to the early eighteenth century, though the Sinhalese may have copied it some years later. The Museum's extensive collection of smallswords (see cat. no. 21) includes several examples made in Japan and possibly Tonkin, China, for the Dutch market and in northern India for the British market. Comparable swords from Sri Lanka are far rarer. At least three in carved ivory are known, but this example in cast and pierced brass appears to be unique.

S W P

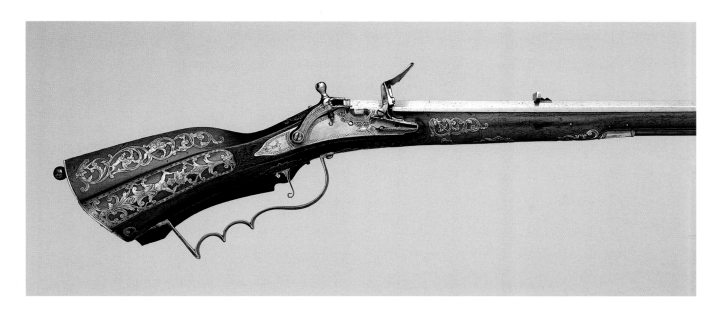

JONAS SCHERTIGER THE YOUNGER (GUNSTOCKER)
SWEDISH, ACTIVE 1715, DIED 1748

18. Snaphaunce Hunting Rifle

Stockholm, dated 1722
Steel, walnut, brass, and horn
L. 43⅜ in. (117.8 cm)
Purchase, Gifts of Albrecht Radziwill and Charles M. Schott Jr., by exchange, and Rogers Fund, 1997 (1997.356)

Ex coll.: Princes of Liechtenstein, Vienna, Feldsberg (Bohemia), and Vaduz; Bashford Dean, New York; William Renwick, Boston and Scottsdale; Clay P. Bedford, Scottsdale; Tom and Ginger Lewis, Evergreen, Colorado
Ref.: Anonymous sale 1926, lot 84, ill.; Hoopes 1940, p. 12, pl. I, fig. f; Lenk 1952, p. 32, fig. 31; Renwick sale 1972, lot 2, ill.; Williamsburg 1977, pp. 217–18, no. 88, ill.; Wennberg 1982, pp. 42–45, ill.; Pyhrr 1998, p. 33, ill.

One of the finest known Scandinavian snaphaunces, this rifle exemplifies the diverse influences shaping firearms design in eighteenth-century Sweden. The gun's slender proportions and small-caliber barrel are modeled after the Silesian Tschinke rifle; the prominent cheek stock is typically German, as is the use of inset brass decoration, but the flat-faced lock copies French models. The form of lock mechanism, on the other hand, is unmistakably Swedish, the snaphaunce traditionally being favored in Scandinavia over the wheellock and flintlock commonly used on the Continent. The decoration, consisting of engraved openwork brass sheet set flush into the stock, reflects both German and French Baroque designs but without apparent reference to the engraved gun-

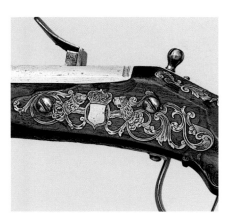

Fig. 7. Sideplate with crowned escutcheon

makers' patternbooks that were so influential throughout most of Europe.

A gunstocker by trade, Jonas Schertiger the Younger was a member of the Stockholm cabinetmakers' guild. His name and date of manufacture are prominently engraved on the brass inlay on the rifle's cheek: SCHERTIGER FECIT 1722. The sideplate (on the side opposite the lock [fig. 7]) includes a blank escutcheon surmounted by a royal crown, a likely indication that this gun was intended for the hunting cabinet of Frederick I of Sweden (r. 1720–51). The weapon subsequently passed into the collections of the princes of Liechtenstein, who were noted hunters and collectors of firearms. S W P

19. Highland Targe

Scottish, first half of 18th century
Wood, leather, brass, horn, and textile
Diam. 19¼ in. (50.2 cm); weight 6 lbs. 5 oz. (2,870 g)
Gift of Jeremy, Christopher, and Robert Douglass, in memory of their father, George A. Douglass, 1996 (1996.83)

Ex coll.: Alfred W. Cox, Glendoich, near Perth, Scotland; R. T. Gwynn, Epsom; George A. Douglass, Riverside, Conn.
Ref.: Campbell 1752, pp. 8–9; London 1931, p. 44, no. 276; Hayward and Blair 1962, p. 84, ill.

In his *Description of the Highlands* published in 1752, John Campbell observed in detail the distinctive appearance and armament of the Scottish warrior, including his plaid coat and kilt and his abundant weaponry, the latter comprising a broadsword, a pair of pistols, and a dirk: "And to finish the Dress, they wear a Target, composed of Leather, Wood and Brass, and which is so strong, that no Ball can penetrate it, and in the Middle of his Target there is a Screw Hole, wherein is fix'd a brass cap lined within with Horn, which serves them to drink out of upon Occasion; and in Time of Action it serves for to fix a Bayonet in. Thus accoutered they make a most splendid and glorious Appearance, it being esteemed by all Judges to be the most heroic and majestic Habit ever wore by any Nation."

The Highland targe, or target, is the latest form of European shield to see use on the battlefield. It last appeared at Culloden (April 16, 1746), when the Jacobites were crushed by the British army, a defeat that led to the Disarming Act passed by the British Parliament in which the Highland way of life, including dress, was proscribed. The Museum's targe probably saw use in this period of rebellion, and its stout construction of several layers of wood bound with leather and reinforced with brass attests to its practical intent. It is one of very few examples to preserve a small removable horn drinking cup beneath the central boss. The leather face of the present shield is lightly tooled; the thin brass plates, arranged in concentric star patterns, are pierced with heart shapes that reveal red velvet beneath, and the surface is studded overall with brass nails, a boldly patterned and colorful decoration perfectly in keeping with the rest of the Highlander's distinctive dress.

This shield and the following pistols (cat. no. 20) are important additions to the Museum's small collection of Highland arms, notable among which are two two-handed swords of sixteenth century date (acc. nos. 45.160.2 and 54.46.10) and one of the earliest and most lavishly embellished snaphance pistols, dated 1612, which belonged to the duke of Curland (acc. no. 46.105). S W P

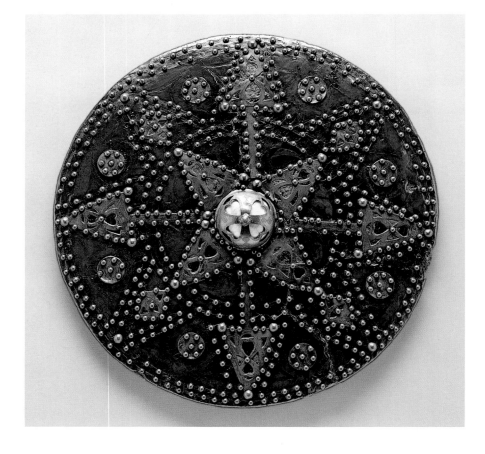

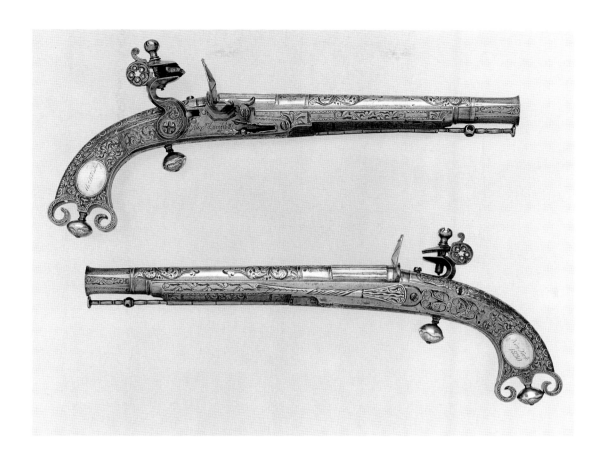

ALEXANDER CAMPBELL
SCOTTISH, DIED 1790

20. Pair of Flintlock Pistols

Scottish (Doune), ca. 1750–60
Steel and silver
L. 11¾ in. (29.8 cm)
Gift of Edward Coe Embury Jr., Philip Aymar
Embury, and Dorothy Embury Staats, in memory
of Aymar Embury II and his wife Jane Embury
Benepe, 2000 (2000.194.1, .2)

Ex coll.: Abraham Bininger Embury (1806–1880)
and thereafter by descent
Ref.: Pyhrr 2000, pp. 32–33.

The Highland warriors of Scotland car-
ried distinctive arms of novel design.
Their pistols, unlike those made else-
where in Britain, were constructed
entirely from metal, either steel or brass,
and were engraved and often silver–
inlaid with geometric and foliate orna-
ment of Celtic inspiration. This pair,
signed by the renowned gunmaker
Alexander Campbell of Doune,
Perthshire, are classic examples of the
type. Among the defining features are the
scrolled "ramshorn" butts with a pricker
(to clean the touchhole) recessed between

the scrolls), button-shaped triggers (with-
out trigger-guards), the decorative
pierced rosette behind the head of each
cock, and a belt hook mounted on the
side opposite the lock. The pistols are
also noteworthy for their American asso-
ciation. The grips are inlaid with silver
plaques inscribed "Abrᵐ B. Embury/New
York 1830," identifying them as having
belonged to a member of a distinguished
New York family. The pistols' unusually
crisp condition testifies to their preserva-
tion as treasured heirlooms for almost
two centuries. S W P

JOHN RADBORN
ENGLISH (LONDON), RECORDED
1737–1780

21. Smallsword

London, hallmarked for 1770–71
Parcel-gilt silver and steel
L. 37⅞ in. (96.2 cm)
Purchase, Rogers Fund, by exchange, 1995
(1995.90)

*Ref.: LaRocca 1998b, p. 34, ills.; Southwick 2001,
figs. 72–73.*

The Metropolitan Museum possesses one
of the finest and most comprehensive
collections of smallswords—the quintes-
sential sidearm of the gentleman between
about 1650 and 1800—thanks to the
magnificent gift of almost one hundred
examples presented by Jean-Jacques
Reubell of Paris in 1926. The majority of
these are French, however, with only two
hallmarked English swords among them.
In recent years the Department of Arms
and Armor has sought to broaden this
collection with the acquisition of a few
representative British smallswords by the
leading London silver-hilt makers or cut-
lers. The most unusual of these is that by
John Radborn, whose cast and delicately
pierced pommel and guard imitate a bas-
ket weave, a design otherwise rarely
encountered among the many extant
London-made hilts of this period.

SWP

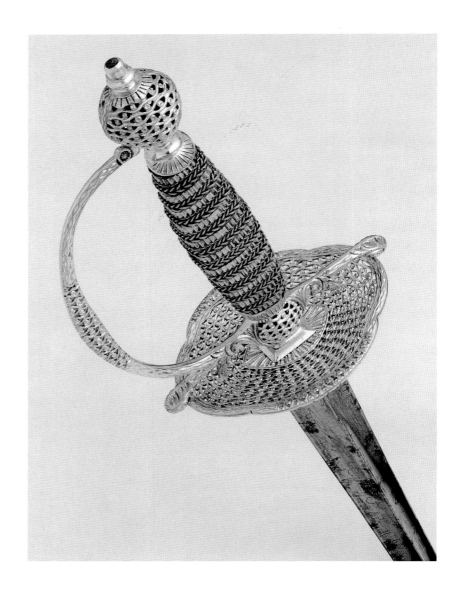

22. Smallsword with Scabbard

French (Paris), hallmarked for 1773–74
Gold, steel, wood, and fish skin
L. (in scabbard) 38⅝ in. (98.1 cm)
Purchase, Annie Laurie Aitken Charitable Lead
Trust Gift, and Gift of William H. Riggs, by
exchange, 1998 (1998.35a, b)

Ref.: LaRocca 1998b, p. 35, ill.; Pyhrr 1998, p. 37,
ill.

Smallswords, like snuffboxes, were an essential element of male costume in the eighteenth century, and their hilts were likewise appreciated as masculine jewelry, made of every possible medium and displaying a wide variety of decoration according to the whim and wealth of the owner. Smallswords with hilts of varicolored gold are infinitely rarer than boxes of the same metal, and well-preserved examples like this one, retaining its original crisp chasing, are exceptional.

The hilt and matching scabbard mounts of yellow and green gold are cast and chased with medallions enclosing profile heads and seated figures of gods (Mars, Minerva, Jupiter, and Hercules [fig. 8]) and personifications of virtues (Justice and Prudence) in the then-current Neoclassical style. The remaining surfaces are enlivened by concave gadroons, a holdover from the preceding Rococo. The goldsmith or chaser remains anonymous, whereas the cutler, or *fourbisseur,* who assembled and retailed the piece, has

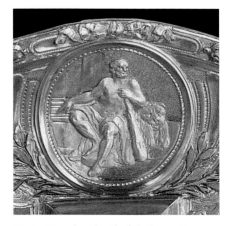

Fig. 8. Hercules (detail of shell guard)

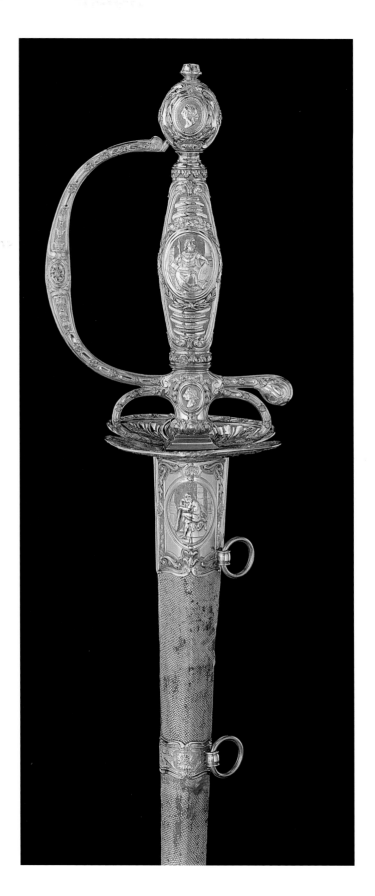

stamped his mark in several places: the letters GG separated by a sword, the point upward, surmounted by a crown, with a dot above each letter. The same *fourbisseur*'s mark occurs on at least five silver-hilted swords bearing hallmarks dating from 1744/45 and 1768/69, none of them approaching the quality or originality of the present hilt. This confirms the likelihood that the Museum's sword was commissioned by a wealthy client and that the cutler subcontracted the design and fabrication of the hilt from specialist craftsmen. SWP

GUILLAUME PAGÉS
FRENCH (PARIS), RECORDED 1709 – 1756

23. Cover for a Smallsword Hilt

Paris, ca. 1750
Leather
8¼ x 6⅞ in. (22 x 17.5 cm)
Purchase, Rogers Fund, by exchange, 1995 (1995.52)

Ref.: Catherine Barne 1995 (letter, Arms and Armor department files, Metropolitan Museum); LaRocca 1998b, p. 33.

A finely made smallsword was sometimes provided with a bag or cover to protect the hilt when the weapon was not in use. In England the bags were sometimes of green baize and were called hoods. This example appears to be the only known hilt bag in leather printed with the name of its supplier, the *fourbisseur* (a cutler and retailer of edged weapons) Pagés. It is constructed of two panels of soft white leather stitched along the top and sides and cut with slots across the bottom edge for a tie, now missing. The face is printed with the *fourbisseur*'s elaborately engraved trade card, now faded but still legible, consisting of an elaborated foliate cartouche enclosing a crowned dolphin set against a background of fleurs-de-lis and flanked by upright swords, with a banderole above inscribed AV DAVPHIN ROYAL . . . (at the [sign of the] Royal Dolphin . . .) and the

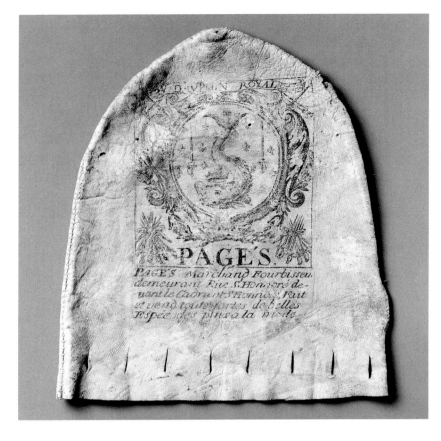

name below, PAGÉS, flanked by bundles of swords, the entire design within a rectangular frame. Inscribed below is an advertisement: PAGÉS Marchand Fourbisseur/ demeurant Rue St. Honnoré de/vant le cadrant S. Honnoré, Fait/en vend toute sortes de belles/Espée des plus a la mode/ A Paris (Pagés, merchant cutler residing at the rue Saint-Honoré in front of the church of Saint-Honoré, makes and sells all types of beautiful swords of the most current fashion in Paris). A cutler by this name is recorded in Paris in 1709, and he may be the same *fourbisseur* Guillaume Pagés who was recorded as residing at the rue Saint-Honoré in the parish of Saint-Germain-Auxerrois in a document of October 1, 1748, and in another, his will, of December 27, 1756, which is probably the year of his death. This unique bag, a delightful piece of eighteenth-century ephemera, is an ideal complement to the Museum's distinguished collection of French smallswords. SWP

SAMUEL BRUNN (GUNMAKER)
ENGLISH, ACTIVE 1795 – 1819

MICHAEL BARNETT (SILVERSMITH)
ENGLISH, 1758 – 1823

24. Pair of Flintlock Pistols

English (London), 1800–1801
Steel, wood, silver, and gold
L. (overall) 16 in. (40.6 cm)
Purchase, Harris Brisbane Dick Fund and Gift of George D. Pratt, by exchange, 1992 (1992.330.1, .2)

Ex coll.: Clarence H. Mackay, New York; William Keith Neal, Warminster, England; Sam Cummings, Manchester, England; [Peter Tillou Works of Art Ltd., London]
Ref.: Mackay sale 1939, lot 7; Blackmore 1960, p. 234, figs. 9 a–c; Neal 1966, pp. 260–61, 265; Blair 1968, p. 105, figs. 285–86; Anonymous sale 1976, lot 5; Blackmore 1991; Tillou 1992, n.p.; Pyhrr 1993, p. 42, ill.

These pistols rank among the most lavishly embellished Neoclassical English firearms known. They are the masterpieces

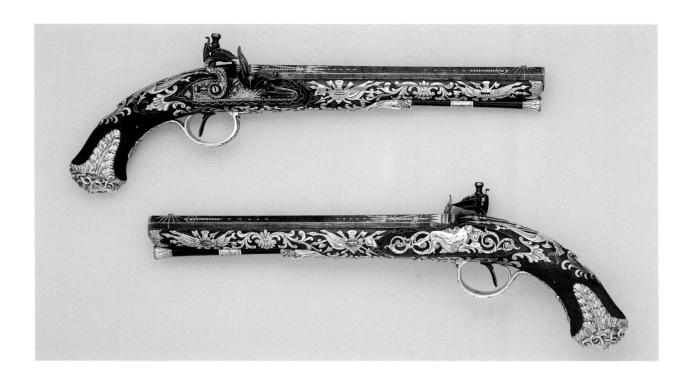

of Samuel Brunn, a leading London sword cutler and gunmaker who held appointments to the Prince of Wales (later Prince Regent and King George IV, 1760–1830) and other members of the royal family, as well as to the government's Board of Ordnance. The barrels and locks are of blued steel engraved and gold-inlaid with trophies of arms and foliage. The decoration of the stocks, combining engraved sheet-silver inlay and heavy cast and chased silver mounts, was inspired by contemporary French Empire firearms. The mounts, the designs of which appear to be unique to British firearms, are the work of a silversmith using the mark M.B., recently identified as the London sword-hilt maker and silversmith Michael Barnett.

Several of the ornamental motifs are based on ancient Roman sources: a nereid riding a sea leopard on the sideplate (fig. 9) derives from an engraving, published in Rome in 1762, of a wall painting found in the ruins of Herculaneum; and the oval medallion on the trigger guard, representing Hercules with a defeated Amazon, is based on an antique gem known from contemporary engravings and casts after the original. The Medusa head on the butt (fig. 10) also derives from classical art, but here the idealized model has been transformed into a grimacing yet almost humorous caricature of the legendary gorgon.

These pistols epitomize the opulence and sophistication of English decorative arts produced during the reign of the Francophile Prince Regent, for whom they were reputedly made. Their acquisition significantly enhances the Museum's small collection of British firearms, most of which, while exemplifying the technical perfection for which English gunmakers were esteemed, lack the decorative qualities for which Continental firearms were so prized. S W P

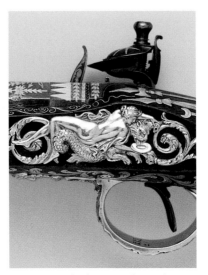

Fig. 9. Nereid riding a sea leopard

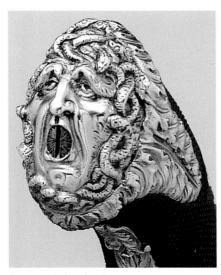

Fig. 10. Medusa head

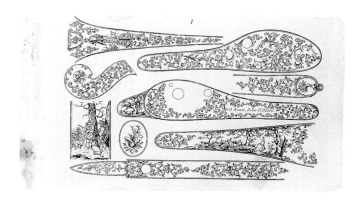

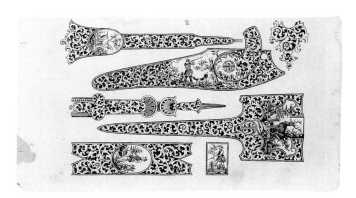

GUSTAV ERNST
GERMAN (ZELLA SANKT BLASII),
ACTIVE CA. 1840–50

25. Two Pages from a Firearms Patternbook

German, ca. 1840
Engraving
7½ x 4⅛ in. (19 x 10.5 cm)
Gift of Herbert G. Houze, 2002 (2002.233.1a–j)

Ex coll.: Louis D. Nimschke; [G. M. Requa];
[J. J. Malloy]; Dr. Richard C. Marohn, Chicago
Ref.: Houze 2002, pp. 24–27.

Pattern books of ornament for use by gunmakers were a French specialty and a number of them were issued by Parisian gunmakers, or the engravers who worked for them, from the early seventeenth to the mid-eighteenth century. These sheets of ornament traveled as far as Spain, England, Germany, Scandinavia, and Russia, carrying with them the French style à la mode, and they remained in use abroad long after they were out-of-date in Paris. Several of the most important pattern books, or individual sheets from dismembered copies, are preserved in the Metropolitan Museum, in the Department of Arms and Armor as well as in the Department of Drawings and Prints. The present newly acquired pattern book by Gustav Ernst is an especially welcome addition to this corpus, as it is a rare German example dating to the mid-nineteenth century whose influence extended far beyond the engraver's native Thuringia.

Ernst's work is titled *Musterblätter enthaltend die anwendbarsten Jagdstücke u. Arabesken für Büchsenschäfter, Graveure, etc.* (Pattern sheets containing the most useful hunting scenes and arabesques for the gunstocker, engraver, etc.) and comprises six loose sheets numbered 1–6. Accompanying these is a title page, unfortunately undated, indicating that it formerly was associated with a set of twelve pages numbered 23–34, proof that Ernst issued many more such prints. The pages of the pattern book illustrate the various metal parts of a percussion gun that could receive engraved decoration, their surfaces covered with complex and elegantly rendered space-filling foliate scrolls and imaginative vignettes of hunters, dogs, and wildfowl. Very similar foliate and figural decoration is in fact found on the German needlefire rifle discussed below (cat. no. 27). Most importantly, however, the pattern book was to play a major role in the evolution of firearms ornament in the United States, where the two leading practitioners of the art, the German-born engravers Gustave Young (1827–1895) and Louis D. Nimschke (1832–1904), freely borrowed and expanded on Ernst's designs. The Museum's pattern book comes from the Nimschke workshop in New York City and so forms a direct link between firearms design in the Old World and the New. The decoration of two recently acquired firearms in the Museum's collection, the so-called Sultan of Turkey Colt Revolver (cat. no. 32), which is an early masterpiece by Young, and the target gun by Grudchos and Eggers (cat. no. 33), includes direct borrowings from this source.

SWP

26. Design for a Naval Presentation Sword

British, ca. 1850–60
Pen and gray wash, heightened in white, on tracing paper
15⅜ x 11⅛ in. (39 x 29.5 cm)
Rogers Fund, 2000 (2000.378)

It was a well-established custom in the nineteenth century, both in Europe and North America, to present swords of honor to distinguished political leaders and military heroes. The finest examples were specially designed by artists who incorporated into the composition motifs appropriate to the recipient and were executed in gold or silver, often at great expense, by the leading goldsmiths or jewelers of the period. Whereas a number of superbly crafted presentation swords exist, original designs for these weapons are seldom preserved. The natural scale of our drawing and its highly finished draftsmanship and colored washes indicate that it was probably

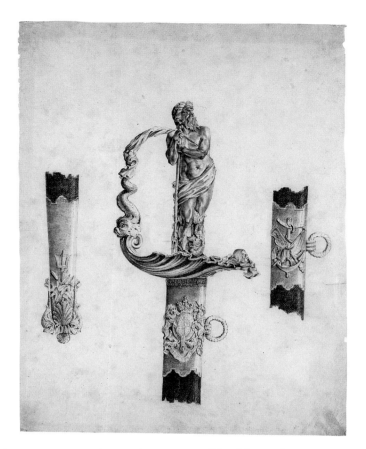

intended as a presentation design of considerable importance.

The grip takes the form of Neptune resting on his trident, the knuckle guard a scrolling dolphin, the guard a scallop shell, and the forward quillon the head of a merman or triton blowing a conch. The scabbard, shown in three sections, includes the top locket with single suspension ring displaying the British Royal Arms (as used from 1837) surrounded by the Garter, the middle locket with ring bearing a fouled anchor with crossed rudder and trumpet, and the chape with shell, bulrushes, and a trident, with the drag formed of dolphins and a shell. (The blade, which would have been etched with appropriate symbols and perhaps a presentation inscription, was the work of a different set of craftsmen and therefore is not shown). The heraldry and aquatic imagery indicate that the sword was intended for presentation to a high-ranking naval officer.

The elaborate imagery appears to have been directly inspired by the designs of Alexandre Gueyton, a Parisian silversmith who published an influential series of designs for swords about 1850. His engraved model for a naval presentation sword includes many of the same nautical images, including Neptune on the grip. Indeed, were it not for the British

arms, this drawing might arguably be identified as French. The ambition of the design and the complex relief work that would have been required for its execution perhaps reflect the influence of leading French silversmiths, specialists in embossed and chased metal, such as Antoine Vechte (1799–1868), who immigrated to England after the Revolution of 1848 and who, therefore, might have influenced its design. This is an early example of what later came to be called a statue hilt, which was especially popular in American Civil War presentation swords, notably those made by Tiffany and Company. S W P

R. BERGER
GERMAN, ACTIVE CA. 1844–70

27. Breech-Loading Needlefire Sporting Rifle

German (Köthen), ca. 1860
Steel, wood, and horn
L. (overall) 45⅞ in. (165 cm)
Gift of Eric Vaule, in memory of Anne Lyman Vaule, 1998 (1998.464)

Ref.: Pyhrr 1999, pp. 44–45.

The nineteenth century witnessed the rapid evolution of European gunmaking, which included the invention of ingenious new ignition systems and the introduction of standardized and therefore

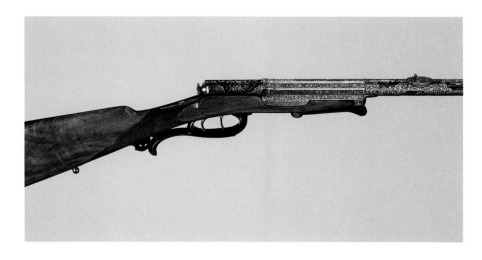

interchangeable machine-made parts. The art of firearms decoration nevertheless continued to flourish and indeed was promoted at the international exhibitions held regularly during the second half of the century. Although French manufacturers dominated the field of richly embellished sporting arms, they were not without competition. One of the more ambitious German craftsmen was the little-known R. Berger of Köthen, who was court gunmaker to Duke Leopold IV of Anhalt-Dessau (r. 1817–71). Berger sent displays to the world's fairs of 1855, 1862, and 1867, where his hunting arms were praised for their modernity of design and quality of decoration. This newly acquired rifle, one of only three nineteenth-century German arms in the Museum's collection, exemplifies these virtues. The extent, variety, and accomplishment of the engraved and chiseled ornament are noteworthy, the mechanism and barrel covered by dense foliate scrolls framing cartouches enclosing trophies of arms, classical and allegorical figures (Diana, Mercury, Justice, and others), and a hunter in contemporary costume. There can be little doubt that this rifle was created as a showpiece for the gunmaker's skills.　　　SWP

J. C. A. BRUN (GUNMAKER)
FRENCH, ACTIVE 1849–72

28. Double-Barrel Breech-loading Pinfire Shotgun

French (Paris), dated 1866
Steel, walnut, and gold
L. (overall) 44⅛ in. (112 cm)
Purchase, The Sulzberger Foundation Inc. Gift and Rogers Fund; Bashford Dean Memorial Collection, Funds from various donors, Gift of William H. Riggs, The Collection of Giovanni P. Morosini, presented by his daughter Giulia, and Gift of Charles M. Schott Jr., by exchange; and gifts and funds from various donors, 1993 (1993.415)

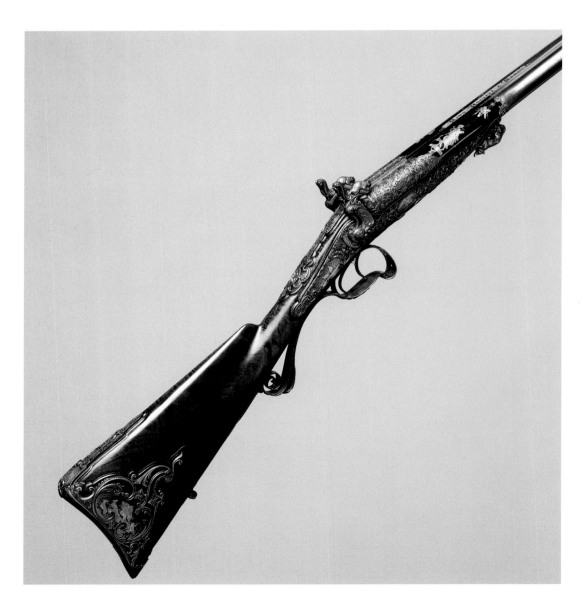

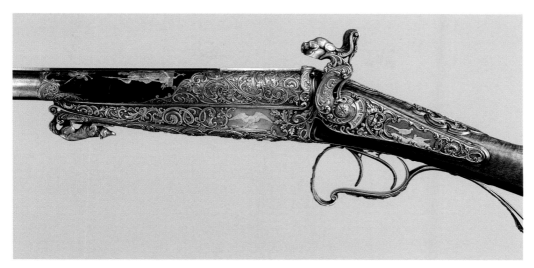

Fig. 11. Detail of lock

Ex coll.: Albert Grosjean (1930–1992)
Ref.: Grosjean sale 1993, lot 55, ill.; Pyhrr 1994,
p. 47, ill.

The Second Empire marked the twilight
of French gunmaking, which had domi-
nated Europe since the time of Louis XIV.
The international exhibitions held in
Paris and London in the 1850s and 1860s
offered French, especially Parisian, gun-
makers the opportunity not only to adver-
tise their skills but also to demonstrate
the place of arms in the decorative (or
so-called industrial) arts. The Paris gun-
makers consistently employed the finest
contemporary designers, goldsmiths,
sculptors, and engravers to transform
functional hunting and target weapons
into works of art.

This exquisitely decorated shotgun
reflects the period's predilection for histor-
ical revivals, in this case the *style Louis XV.*
Especially noteworthy is the harmoni-
ous combination of Rococo ornamental

vocabulary and blue-and-gold coloring,
which together evoke eighteenth-century
taste. Exhibited by Brun at the Exposition
Universelle of 1867, the gun is, in fact, a
collaborative work by some of the lead-
ing artists and craftsmen of the time:
the damascus twist barrels by Léopold
Bernard; the gun's design and its intri-
cately chiseled steel mounts by the silver-
smiths Auguste and Joseph Fannières
(fig. 11); and the delicate engravings on the
barrels and mounts, encrusted in two-
color gold, by the engraver Tissot (fig. 12).

Until recently the nineteenth cen-
tury was very poorly represented in the
Museum's collection of European fire-
arms. A conscious effort has been made
to fill this gap with the acquisition of a
few select pieces that exemplify the high-
est level of design and craftmanship in
that fertile period. The Brun shotgun
satisfies these requirements admirably
and is one of the masterpieces in the
Metropolitan's collection. S W P

Fig. 12. Detail of butt

29. Six Armor Scales from New Mexico

Probably Spanish, 15th to 16th century
Iron and wool
1 x 1⅝ in. (2.5 x 4 cm) each
Gift of Mr. and Mrs. Raymond E. Willerford,
1998 (1998.366.1–6)

Ref.: Rogers and LaRocca 1999.

These six scales come from a group of approximately three to four hundred recovered from a region of New Mexico that the Spanish explored and later colonized during the sixteenth and seventeenth centuries. Originally the scales would have been riveted in an overlapping pattern, like shingles, to the outside of a leather or textile jacket (traces of fiber, apparently wool, remain under some of the rivet heads). They are important as the only examples of scale armor to have been found in the New World. They are also interesting because they represent a form of armor that appears to have stopped being used in Europe well before the colonization of the American Southwest.

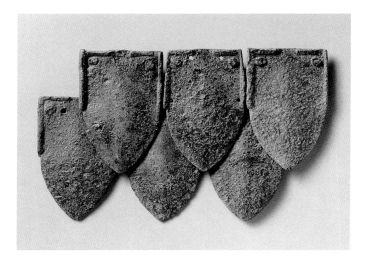

Scale armor is an extremely ancient form of defense, with surviving fragments from the Middle East dating as early as about 1700 B.C. In Europe variations of scale armor were used from the Roman period through the end of the Middle Ages. Full-torso armor of scale went out of fashion after the mid-fourteenth century A.D., but some scale armor continued to be made and worn in certain circumstances as late as the seventeenth century. The coat of scales from which

the Museum's examples must have come was probably outdated by two or three generations when it was brought to New Mexico, presumably on a Spanish expedition of the late sixteenth or early seventeenth century. The armor most likely was worn by a soldier of modest means who could not afford more up-to-date equipment, as was the case with many soldiers who came to the New World to seek their fortunes.

DJL

30. Flintlock Gun

American, about 1740–50
Steel, brass, and wood
L. 77¼ in. (196.2 cm)
Gift of Dean K. Boorman, 2001 (2001.560)

Ex coll.: John Dean and thereafter by descent

This gun is notable for its great length—nearly six and a half feet—and for several

stylistic features that make it attributable to New York. It is further distinguished by its historical association with John Dean (1755–1816), a sergeant in the Continental army during the American Revolution, who participated in the capture of the British spy Major John André. Although made for hunting, this gun could well have been carried by Dean during the Revolution. Like

many American firearms of the Colonial period, it is fitted with an imported French lock, in this case a model 1728 made in the royal arms manufactory at Saint-Étienne (fig. 13). The gun was handed down through the Dean family, a member of which, Dr. Bashford Dean (1867–1928), was first curator of the Metropolitan's Department of Arms and Armor.

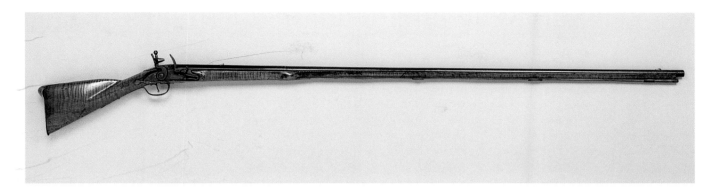

Flintlock guns of this type are referred to as "Hudson Valley fowlers," which is indicative of their region of origin and their intended function. The extremely long barrel was well suited for the needs of hunting wildfowl in the marshlands found along much of the Hudson River valley. Most flintlocks of this type were later shortened to a more manageable length and converted from flintlock to percussion. This gun is one of the rare examples to have survived from the Colonial period with both its original length and its original French lock intact.

DJL

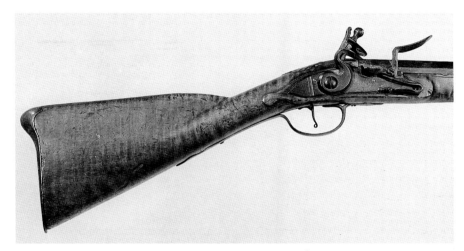

Fig. 13. French lock from the royal arms manufactory at Saint-Étienne

THOMAS FLETCHER
AMERICAN, 1787–1866

31. Design for an Officer's Sword

American (Philadelphia, Pennsylvania),
dated 1837
Pen and wash on paper
20⅛ x 18¼ in. (51 x 46.2 cm)
Rogers Fund, 1995 (1995.38)

Original designs for American dress swords are particularly rare. Until recently the largest single group by any one craftsman consisted of three surviving drawings signed by the silversmith Thomas Fletcher. The present drawing is a previously unrecorded variant of one of those three, adding a fourth sword design to the group. Fletcher is best known for

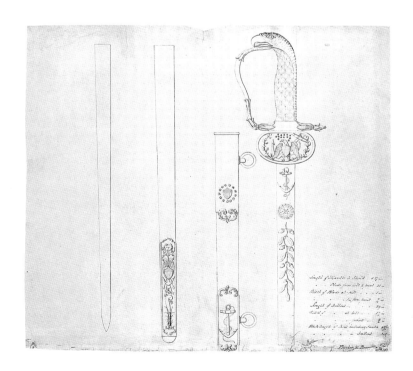

his work while in partnership with Sidney Gardiner (1785–1827). The firm is recorded in Boston directories for 1808 and 1810, but little is known of their work there. After relocating to Philadelphia in 1811, however, Fletcher and Gardiner rapidly became established among the elite jewelers of the city and eventually gained a national reputation for the quality and design of their wares, which included some of the most elaborate American presentation silver made during the Federalist period.

A decade after Gardiner's death, Fletcher entered into a brief partnership with Calvin W. Bennett from 1837 to 1839. The signature line on the Museum's drawing, although partially damaged, includes the names of both Fletcher and Bennett, making this one of the few documented products of their partnership. From right to left the drawing shows the hilt and upper half of the blade, the upper half of the scabbard, the bottom half of the scabbard, and the bottom half of the blade. In the lower-right-hand corner of the drawing the precise measurements of the various components are given. An extremely similar drawing preserved in the Maryland Historical Society, Baltimore, is identified in an inscription as a post captain's sword. It is also dated 1837 but bears only Fletcher's name. The addition of Bennett's name and the slight changes on the Museum's drawing suggest that it was revised solely to reflect the new partnership, presumably as a submission for a potential government contract for officers swords.

<div align="right">DJL</div>

SAMUEL COLT
AMERICAN, 1814–1862

GUSTAVE YOUNG
AMERICAN, 1827–1895

32. Colt Third Model Dragoon Revolver, serial no. 12406, and case

American (Hartford, Connecticut), ca. 1854
Steel, brass, gold, wood, and textile
L. 14 in. (35.6 cm)
Gift of George and Butonne Repaire, 1995
(1995.336)

Ex coll.: Sultan Abdülmecid I, Istanbul, Turkey; [Herb Glass, Bullville, New York]; William M. Lock, Cincinnati; [Herb Glass]; George and Butonne Repaire, El Sobrante, California Ref.: Wilson 1974, pp. 104–9, ill.; Wilson 1979, pp. 136–137, ill.; Pyhrr 1996, p. 49, ill.; Wilson 1997; Wilson n.d., frontispiece, pp. 197–201.

Colt patented the first mass-produced multi-shot revolving firearms, thereby gaining enduring fame as one of America's most successful inventors and entrepreneurs. His standard revolvers were works of precision and reliability, highly valued by soldiers and frontiersmen, and his deluxe arms, made for exhibition or presentation, were appreciated for their elegant engraved decoration. The present pistol is one of only a handful of gold-inlaid examples and is considered one of Colt's finest works.

The ornament is the invention of the German-born engraver Gustave Young, whose crisp and elegant scrollwork set the standard for all future American firearms decoration. The gold inlay includes a bust of George Washington set flush into the cylinder and the arms of the United States in low relief on the

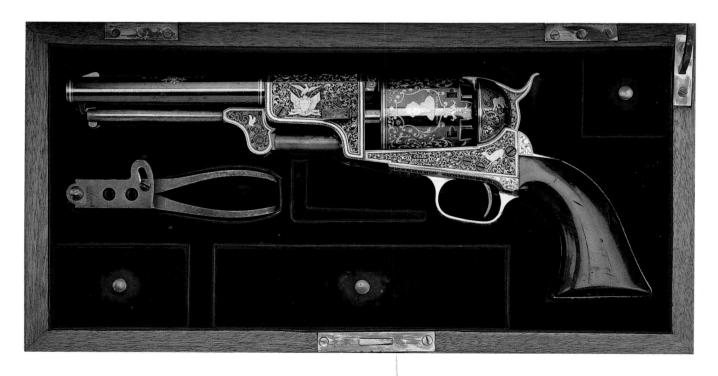

frame. Complementary imagery is found on the mate to the Museum's pistol, serial no. 12407, in the State Hermitage Museum, Saint Petersburg. The pair was split in 1854, during the Crimean War between Russia and Turkey, when Colt presented one to Czar Nicholas I and the other (the present gun) to Sultan Abdülmecid I. Although intended to promote sales by demonstrating the technical and artistic qualities of Colt's products, the patriotic motifs of these gifts also proudly proclaimed their American origin.

Without doubt the most important single gift to the Metropolitan's Department of Arms and Armor in the last half century, the so-called Sultan of Turkey Colt has become the centerpiece of the Museum's small collection of American arms. There it is complemented by a select but representative group of Colt revolvers dating between 1835 and 1875 that were presented years earlier by the pioneer Colt collector John E. Parsons. Like Parsons, the donors of the Sultan of Turkey Colt considered the Metropolitan Museum of Art the ideal public repository for this icon of American arms.

SWP

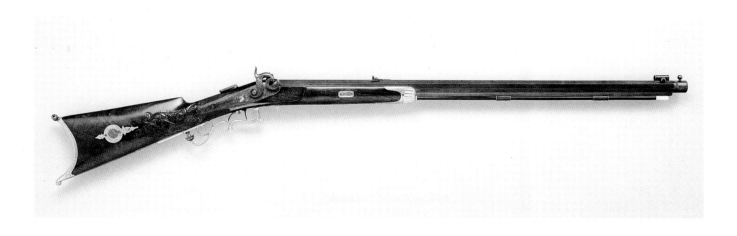

JULIUS GRUDCHOS AND
SELMAR EGGERS
AMERICAN, ACTIVE CA. 1856–60

33. Percussion Target Rifle

American (New Bedford, Massachusetts), ca. 1856–60
Walnut, steel, silver, gold, ebony, and ivory
L. 49¼ in (125.1 cm)
Purchase, Bashford Dean Memorial Collection, Funds from various donors, by exchange, 1992 (1992.375)

Ex coll.: Albert Goodhue, Jr.
Ref.: Goodhue sale 1992, lot 71; LaRocca 1993b, pp. 58–59, ill.; Wilson 1995, p. 85, ill.

Target shooting with the crossbow was a well-organized sport in Germanic countries by the late Middle Ages. Shooters formed clubs that were modeled after contemporary craft guilds and served many of the same social and civic functions. During the late fifteenth century firearms gradually replaced bows as the customary weapon for target shooting in most areas. This activity being a long-established part of their society, German immigrants in the nineteenth century quickly founded shooting clubs (*Schützenvereine*) in the United States. Such clubs remained a popular fixture of German-American culture into the early twentieth century.

Most *schützen* rifles were relatively plain, unlike this finely made, unusually decorative example. It is distinguished by delicate floral ornament engraved on the steel and silver mounts, gold inlay highlighting the browned barrel and lock, and exuberant floral designs carved in the stock. Grudchos and Eggers, whose names appear on the lock and barrel, were well known for their innovative whaling guns. All the elements of the target rifle are stamped with number 1, suggesting that it was the first of the few firearms of this specialized type that Grudchos and Eggers made during their brief partnership.

DJL

ISLAMIC WORLD

WORKSHOP OF
AHMED TEKELÜ
IRANIAN (?), ACTIVE IN
ISTANBUL, CA. 1520–30

34. Yataghan

Turkish (Istanbul), ca. 1525–30
Steel, walrus ivory, gold, silver,
rubies, turquoise, and pearls
L. 23⅜ in. (59.3 cm)
Purchase, Lila Acheson Wallace Gift,
1993 (1993.14)

Ex coll.: Rex Ingram (1893–1950)
Ref.: Pyhrr 1993, pp. 20–21, ill.

Exquisite workmanship and opulent use of precious materials distinguish this sword as a princely weapon. It is almost identical to a yataghan made in 1526–27 by the court jeweler Ahmed Tekelü for the Ottoman sultan Süleyman the Magnificent (r. 1520–66). Indeed the parallels between Süleyman's sword, now in the Topkapi Palace, Istanbul, and the Museum's acquisition are so strong that the two can be confidently ascribed to the same imperial atelier.

Employing the diverse talents of the bladesmith, ivory carver, goldsmith, and jeweler and incorporating decorative motifs found in contemporary Ottoman painting, this yataghan is a microcosm of the luxury arts produced at Süleyman's court. The ivory grip is inlaid in gold with a pattern of intersecting cloud bands, with gold flowers, their centers set with turquoise and rubies, in the pommel. The gold ferrule at the base of the grip is chased with floral scrolls against a recessed matte ground. The curved blade is decorated on each side near the hilt with a long palmette-shaped panel enclosing designs encrusted in gold against the blackened steel ground. The high-relief gold incrustation found on this and the related yataghans mentioned below appears to be unique in Ottoman metalwork. Within each panel a scaly dragon attacks a phoenix (or *sen-murv*), the combat set against a forest of dense foliate scrolls (fig. 14). The liveliness of these fantastic creatures is enhanced by engraving and deeply undercutting the anatomical parts and by such details as ruby eyes, the silver teeth of the dragon, and the pearl set into the head of the phoenix. A gold-inlaid Persian inscription on the spine of the blade remains to be deciphered. This inscription and the Chinese-inspired cloud band and dragon-and-phoenix motifs reflect the strong influence of Iranian art, which incorporated many central Asian traditions. It has been suggested that Ahmed Tekelü may have been Iranian and was one of the highly prized craftsmen conscripted from Tabriz following its conquest by the Ottomans in 1514.

This is one of the earliest known yataghans, distinctly Turkish short swords that are characterized by a double-curved blade and a guardless hilt. Yataghans were commonplace in Anatolia and the Balkans in the eighteenth and

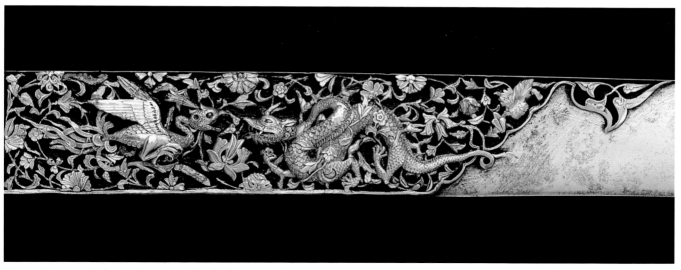

Fig. 14. Dragon and phoenix in combat (detail of cat. no. 34)

nineteenth centuries, serving as a standard side arm for the Janissaries. Until recently, however, Süleyman's yataghan was thought to be the unique sixteenth-century example. Three more gold-encrusted yataghans have since come to light: the present one and two now in private collections. Of the latter, one has a blade decorated solely with Arabic inscriptions that include the name of Sultan Bayazid II (r. 1481–1512). The other is decorated with dragon-and-phoenix motifs virtually identical to those on the Süleyman and Metropolitan swords; it is inscribed in Arabic with the name of Grand Vizier Hersekzad Ahmed (1456–1517), who is thought to have received it from Sultan Selim I in 1517. The Museum's yataghan, though lacking the owner's name, was undoubtedly commissioned by the sultan, probably for presentation to a high-ranking courtier.　　　S W P

35. Parade Helmet

Turkish, Ottoman period, possibly early
17th century
Gilt copper
H. 8¾ inches (22.2 cm); wt. 2 lb. 8 oz. (1,139 g)
From the Collection of Nina and Gordon
Bunshaft, Bequest of Nina Bunshaft, 1994
(1995.68)

Ex coll.: Gordon Bunshaft, New York (acquired
in Istanbul in 1971)

There appeared in the sixteenth century a new type of armor worn by the Ottoman warrior that was unlike any seen elsewhere in the Islamic world: helmets, shields and chanfron (horse's head defenses) made entirely of gilt copper, *tombak* in Turkish. The medium was employed purely for its colorful effect and ostentation, so that the armor can have been intended only for ceremonial

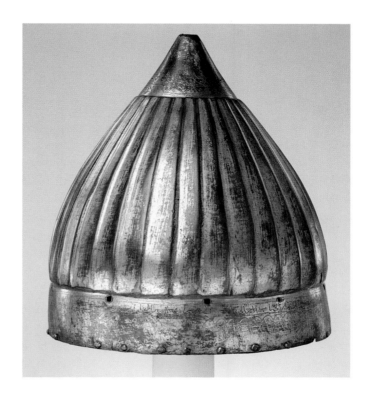

use, possibly for the sultan's bodyguard. Until recently, the Metropolitan possessed two incomplete helmets (36.25.125, 1974.118) and three chanfrons (21.102.3, 36.25.496, and 36.25.507) in *tombak*. While the present helmet is a modest example of this genre and, like many Ottoman helmets, has since lost its applied brim, nasal bar, and suspended nape defense and cheekpieces, not to mention its finial, it nevertheless is a useful addition to our collection of Islamic arms because of its unusual form and its inscription. While the majority of Turkish helmets are of modified conical shape, this one is noteworthy for the simulation of vertically overlapping plates, a type of helmet construction found in Central Asia and elsewhere (see cat. no. 41). The lower edge and apex, which are slightly stepped in from the middle zone, are decorated with punched geometric and stylized foliate ornament. The lower edge for about one-quarter of its circumference also bears a punched inscription in Arabic that reads in translation, "What was made for His Excellency the emir ʿUthmān, the banner-bearer, son of the emir ʿAlī." Despite its now rough condition, this helmet evidently belonged to a high-ranking Ottoman officer, one whose identity and dates of service remain to be discovered. SWP

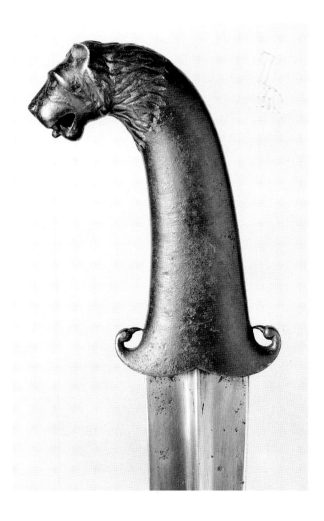

36. Dagger

Indian, Mughal period, 17th century
Steel and silver
L. 14⅛ in. (36 cm); weight 13 oz. (363 g)
Purchase, The Sulzberger Foundation Inc. Gift, 1994 (1994.26)

Seventeenth-century Mughal miniatures frequently show hunters and courtiers wearing elaborate and colorful daggers with hilts terminating in animal-head pommels, most often horses but occasionally also nilgai (water buffalo), camels, or birds, usually rendered in jade, ivory, or even rock crystal and often set with jewels. This dagger belongs to that courtly milieu but is unusual, if not unique, for its materials, construction, and iconography.

The hilt is of dark iron and is constructed of multiple sections joined by copper brazing. The curved "pistol" grip of oval section is formed of two halves to which were added the turned-back quillons shaped as stylized birds' heads and the lion-head pommel, which itself is formed in several sections. The lion's head is naturalistically rendered, with carefully delineated features that include an open mouth with individual teeth and a projecting tongue. The hollow eye sockets and a circular recess between the ears undoubtedly once held inlays of some sort, presumably jewels. Traces of silver on the mane suggest that the hilt was originally partly silvered as well. Faint transverse striations across the center section of the hilt are probably evidence that it was once wrapped with a textile so as to provide a surer grip and which, with the passage of time, subtly corroded the iron beneath. SWP

37. Coat of Mail and Plate

Indian, 17th century
Steel
H. 35⅛ in. (90.5 cm)
Purchase, Arthur Ochs Sulzberger Gift, 2000
(2000.497)

Ex coll.: Bikaner Armory

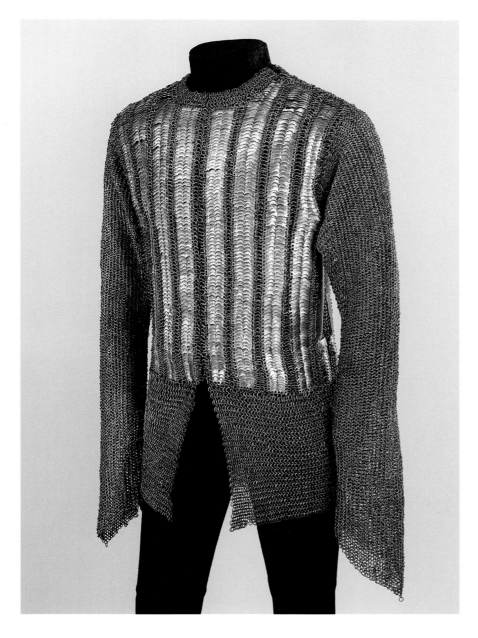

Armor composed of steel plates joined by areas of mail appears to have been developed first in Iran or Anatolia during the early fifteenth century. Variations with plates of different sizes and configurations were being worn in many parts of the Ottoman Empire by the sixteenth century and versions of it were adopted in Russia, where they remained in use at least through the end of the seventeenth century. The style was probably introduced into India early in the Mughal period due to the Ottoman influence on Mughal military practices. Typical examples have four to eight large plates on the chest and rows of smaller plates on the back. Coats of mail with many closely set rows of small plates on both the chest and the back are more unusual, particularly in India, and may not have come into use until the seventeenth century. This mail shirt, with its neatly cusped and scalloped plates, is a very rare and elaborate example of what may be a specifically Indian variation of this otherwise widespread style.

This armor is part of a large group of material that comes from the ancestral armory of the maharajas of Bikaner in Rajasthan, northern India. Many of the armors from Bikaner have inscriptions in Hindi and Persian, which give the dates and campaigns in which they were captured as booty. The inscription on this armor names the maharaja of Bikaner, Anup Singh (d. 1698), and has the date *samvat* 1774 (A.D. 1691). Anup Singh was a general in the armies of the Mughal emperor Aurangzeb and one of Bikaner's most famous rulers. He led an extensive series of campaigns in the Deccan in the 1680s and 1690s, including battles at Golconda in 1687 and Adoni in 1689. The date on this armor indicates that it must have been taken as booty during one of the Deccani campaigns, although neither the specific battle nor the city is mentioned. DJL

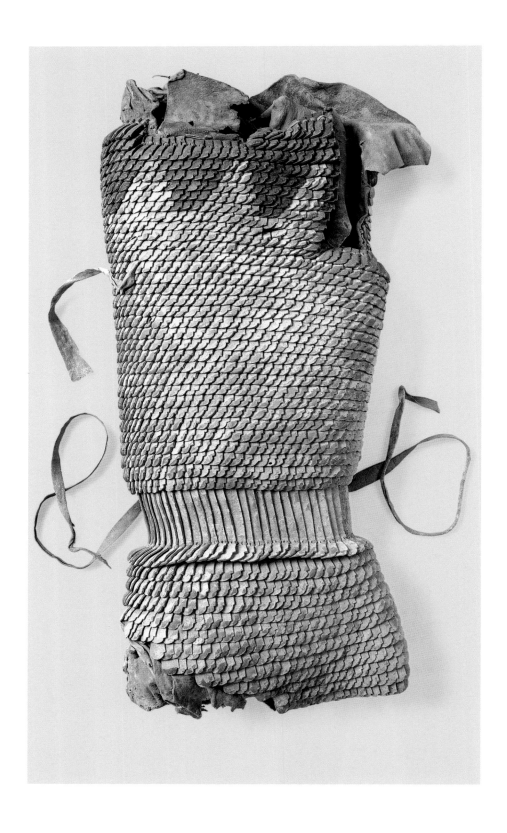

38. Scale Armor

Eurasian, ca. 6th century B.C.
Leather
L. 27¾ in. (70.5 cm)
Purchase, Arthur Ochs Sulzberger Gift, 2000
(2000.66)

Ref.: LaRocca 2000, pp. 14–15, ill.

Not only is this extraordinary armor the best-preserved scale armor from antiquity, but it is also the single known example entirely of leather that survives from such an early period. It consists of a sleeveless garment made of fifty-six rows of hard scales, which are secured by rawhide laces to a soft leather lining. The armor reaches from the shoulders to the upper thighs, with a wide band at the waist. It wraps around the torso and overlaps on the right side. Leather laces, by which the armor would have been tied closed, are found at the side of the chest and at the small of the back. A subsidiary skirt, consisting of several layers of soft leather (not visible in the photograph), is stitched to the interior lining at the bottom edge of the armor. This skirt would have reached to just below the wearer's knees. The positioning and extent of the skirt were only revealed during the conservation treatment of the armor, which is ongoing.

Historically scale armor, usually of bronze or iron, was among the most long-lived and widely used forms of protection. It first appeared in Egypt and the Near East about the middle of the second millennium B.C. and continued to be worn in Europe as late as the seventeenth century A.D. Based on the style and construction of the Museum's example, it seems most likely that the armor was made by one of the nomadic cultures of Eurasia—possibly the Scythians, who dominated the steppes from the sixth to the second century B.C. DJL

39. Short Sword (*Duan Jian*)

Eastern Central Asia, ca. 4th–1st century B.C.
Steel, bronze, and gold
L. 26⅛ in (67 cm)
Purchase, Bashford Dean Memorial Collection, Funds from various donors, by exchange, 1998
(1998.418)

Ref.: Milleker 2000, p. 159 ill.

From its inception in the third millennium B.C., the sword served both as a weapon and as a symbol of societal status and power. During the first millennium B.C., in the hands of the nomadic peoples of the Eurasian steppes, it became, along with the bow, one of the primary cavalry weapons of the ancient world. Such groups as the Scythians, the Yuezhi, the Xiongnu, and the Xianbei were able to achieve a succession of federations and kingdoms in Eurasia by combining the use of sword and bow with an unparalleled skill in horsemanship. Archaeological investigations of burial sites have established the importance of the sword as both a valued possession and a sign of rank in various nomadic societies. While some sword forms can be identified with specific nomadic peoples through consistent characteristics of the burials in which they are found, the owners of other examples, such as this one shown here, remain less certain. The bronze hilt of this sword has several distinctive features, including a domed pommel with nonzoomorphic ornament, a pebble-textured hourglass grip, and, extending from the grip, a socket with concave sides from which the double-edged steel blade emerges. The socket is divided into compartments, a number of which are inlaid with gold foil. The hilt is made in two halves seamed longitudinally up the sides. It has been brazed or cast directly onto the tang of the blade, which passes up through the entire length of the socket.

The complex techniques required for the manufacture of this sword, the combined use of bronze and steel, and the

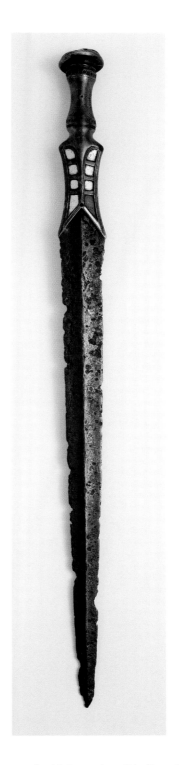

presence of gold decoration all indicate its origin in a society with advanced metal-working skills and a relatively high level of material wealth. The technology to produce iron and steel existed in China by about the sixth century B.C., although

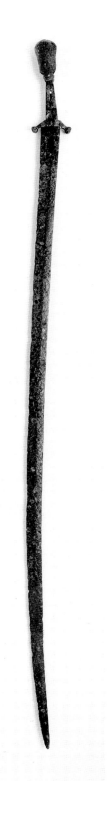

those metals were not used for weapons before the fourth century B.C. Swords similar to this one have been found in Ningxia in northwestern China and in Yunan in southwestern China. Since the Ningxia finds also include many other examples of similarly advanced metalworking, this sword may have originated in that region, perhaps around the time of the late Warring States period. DJL

40. Saber

Eurasian, 9th to 12th century
Iron
L. 48 in. (122 cm)
Purchase, Arthur Ochs Sulzberger Gift, 2000
(2000.609)

Sabers of this type are extremely rare, with very few existing outside of Central European and Russian collections. This example is representative of an early form of saber which was carried by Turkic and Mongol tribes from the steppes of Mongolia through China, Central Asia, and the Middle East and into Russia and Eastern Europe. As a consequence it had a significant and far-reaching impact on the development of sword forms throughout these regions. This saber is the only example of its type and period in the Museum's collection and serves as a stylistic and typological link between the Museum's holdings of Asian, Middle Eastern, and European swords.

Defining characteristics of this early form of Eurasian saber are the long, slender, and only slightly curved blade and the back edge (a short portion of the back of an otherwise single-edged blade, which is sharpened near the tip). Other typical elements (see fig. 15) are the L-shaped collar at the very base of the blade where it meets the guard; the short quillons (arms of the guard) with knob finials; the slightly drooping angle of the tang (the extension of the blade on which the grip is mounted); and the pear-shaped pommel.

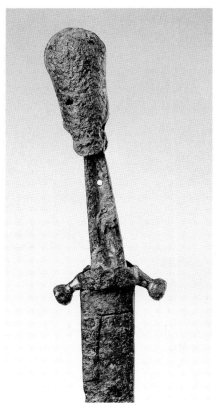

Fig. 15. Detail of the hilt

The most famous and most well-preserved saber of this type is perhaps the Sword of Charlemagne (Weltliche Schatzkammer, Vienna), which is thought to be from the Avars of Eastern Europe and probably dates to the eighth century. DJL

41. Lamellar Helmet

Tibetan or Mongolian, 13th to 15th century
Iron and leather
H. 5½ in. (14 cm); diam. 9 in. (22.9 cm)
Purchase, Gift of William H. Riggs, by exchange and The Sulzberger Foundation Inc. Gift, 1999
(1999.158)

Ref.: Gutowski 1997, pp. 24, 48, pl. 9.

The term lamellar refers to armor made up of many small thin plates, which are generally rectangular in shape, usually

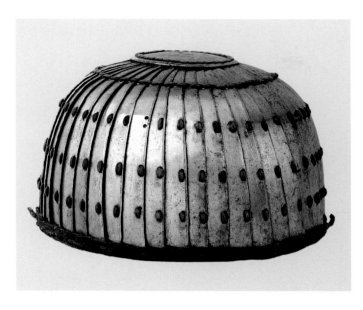

with rounded ends, and which are pierced by holes through which leather lacing is passed to join the plates together. Like scale armor (see cat. no. 38), lamellar armor was widely used in the ancient world, possibly originating in the Near East and spreading rapidly throughout Asia. Lamellar differs from scale armor in two principal ways. First, in scale armor the individual scales are laced, tied, or riveted to a lining of some sort, usually cloth or leather. In lamellar armor, however, the individual lamellae are laced only to one another; no support fabric or lining is necessary. Second, scales overlap downward, like the shingles on a roof, but lamellae always overlap upward. These characteristics make lamellar armor much more flexible and versatile than scale. As was the case with scale armor, the earliest lamellar armors were probably made of hard leather and then of bronze and later of iron. Various forms of lamellar armor were known from as early as the ninth century B.C. It was a primary form of body armor across the Eurasian steppes for a thousand years from about the fifth century A.D onward, and in some remote areas, such as Tibet and Siberia, it remained in use until the early twentieth century.

This lamellar helmet from Tibet is composed of forty-six individually arched iron lamellae, each of which is pierced by sixteen lacing holes. The lamellae are tightly joined by six rows of intricate leather lacing and meet at a circular plate at the top of the skull. The earliest helmets of this type consist of a few fragmentary examples, dating from the fifth and sixth centuries A.D., which have been excavated in Central Asia. The type is also occasionally depicted in sculpture, frescoes, and other works of art from about the same time onward. Of the few surviving examples not in excavated condition, this helmet is remarkable for its completeness and state of preservation. In this it is unlike most armor and weapons from Tibet, which typically show evidence of repairs and alterations from use over several generations. It may have been preserved in a context such as a treasury or votive chapel, where it would have remained unused over the centuries. The bright exterior surface of the helmet is its original finish. Its nearly pristine state is unparalleled on a ferrous metal object from this period. The surface survived because it was protected by a hard layer of uniform corrosion, probably magnetic oxide, which can form on pure iron under the right conditions. The satinlike luster of the iron was only fully revealed, however, after more than two hundred hours of painstaking cleaning at the Museum, which was carried out in the Arms and Armor Department by the late Robert M. Carroll and Hermes Knauer.

DJL

42. Arm Defense with Iron Fittings

Tibetan, 14th to 16th century
Leather, polychrome, and iron
L. 10 in. (25.4 cm); w. 6⅛ in. (15.6 cm)
Purchase, Kenneth and Vivian Lamb Gift, 2001
(2001.36)

Leather armor was widely used in both Europe and Asia for many centuries. Despite this, only a handful of early pieces have survived from either culture.

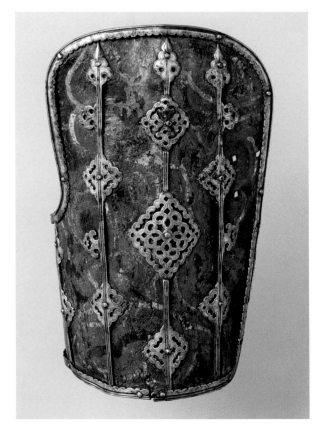

This arm defense is part of a very small group of closely related arm defenses from Tibet, all of which appear to have been made for the left arm. Unusual as it is, this piece offers several close points of comparison with other types of Tibetan objects. The decoration on the iron ribs is similar to that found on an early group of Tibetan wicker shields (cat. no. 43). The pierced ironwork technique also compares well with that used to produce the pierced and engraved iron-filigree panels on the Museum's Tibetan horse-armor elements (cat. no. 46). In addition, both its painted leather surface and its iron fittings are very similar to those found on Tibetan leather boxes and wooden furniture, some of which have been shown to date from the fourteenth to the sixteenth century. This common thread of workmanship may eventually be instrumental in more closely identifying the period and source of these poorly understood groups of objects. D J L

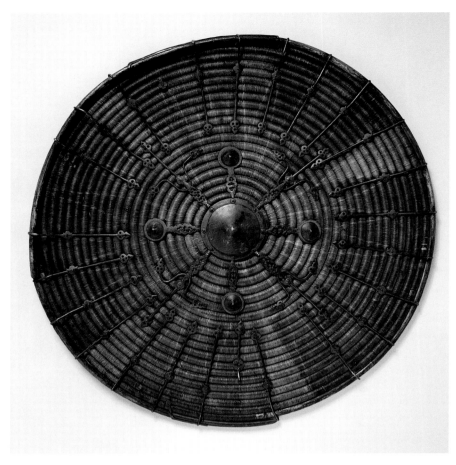

43. Wicker Shield with Iron Fittings

Tibetan, 14th–16th century
Wood, iron, and brass
Diam. 29⅞ in. (75.9 cm)
Purchase, Arthur Ochs Sulzberger Gift, 2001
(2001.55)

Ref.: LaRocca 2001, p. 83, ill.

Wicker shields are made of tight concentric rings of narrow, spirally wound wooden rods. They were widely used in both Persia and Turkey up to the eighteenth century and are well represented in Islamic art and by many surviving examples. It is less well known, however, that distinctive types of cane shields were also employed, from perhaps as early as the fourteenth century, in Tibet, where they continued to be used as military equipment until the early twentieth century and as ceremonial objects as late as the 1950s. Despite their longevity Tibetan wicker shields with pierced and decorated iron fittings are extremely rare. The fittings, which are practical as well as ornamental, can vary widely in their quality and complexity. This example is one of the best preserved and more elaborate of its type. The iron fittings are closely related to those found on Tibetan leather boxes, certain types of Tibetan wooden furniture, and a few rare examples of Tibetan leather armor (cat. nos. 42 and 46). The shield is therefore important not only as an example of Tibetan arms but also as an instance of the interrelationship of Tibetan metalwork and other decorative arts. D J L

44. Sword (*ral gri*)

Tibetan, 14th to 16th century
Iron, steel, gold, and silver
L. 34⅞ in. (88.6 cm)
Purchase, Rogers Fund and Fletcher Fund, by
exchange, 1995 (1995.136)

Ref.: LaRocca 1995, p. 77, ill.; LaRocca 1996,
pp. 15, 42, fig. 9; Richardson 1996, p. 99, fig. 6;
Lavin 1997, pp. 14–15, figs. 3, 4; LaRocca 1999b,
p. 122, fig. 17.

This sword's hilt has a very distinctive
and rare form, which, in combination
with the choice of motifs and decorative
techniques, suggests a Tibetan origin. It
is made entirely of iron, including the
grip, an unusual feature in that sword
grips are typically made of a wooden core
wrapped in leather, textile, or braided
wire. The all-iron construction and the
shape of the hilt are reminiscent of some
early Chinese types. The pierced, chis-
eled, and damascened decoration is a fine
example of a style of ornamental iron-
work that flourished in Tibet from at
least the late Yuan dynasty (1279–1368),
perhaps indicating some Mongol
influence in its development.

The decorative motifs are chiseled in
relief and highlighted by damascening in
gold and silver. The damascening is done
by scoring the surface of the iron overall
with a minute pattern of crosshatched
lines. Fine gold and silver wires are then
laid into respective areas of the cross-
hatching and burnished into place.
Among the more prominent motifs, the
pommel features a characteristic monster
mask (Tibetan *dziH pa tra* or *dzi bar*)
with appended hands grasping serpentine
tendrils that issue from its mouth. This
auspicious symbol is derived from the
Indian *kirtimukha* (face of glory) and is
widely used in the decoration of Tibetan
art. The mask on the semicircular guard
at the base of the hilt is both leonine and
dragonlike. Its eyes, nose, teeth, and
fangs appear to dissolve into a back-
ground of scrolls, suggesting the face of a
snow lion or a dragon amid the clouds.

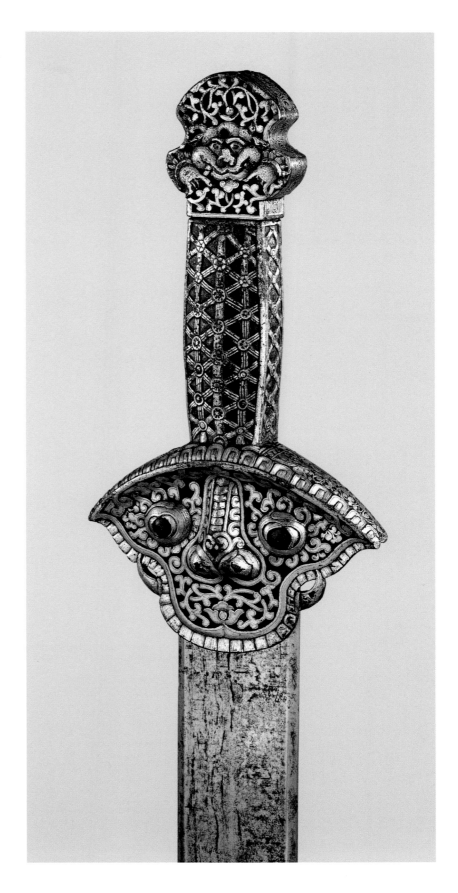

The straight double-edged steel blade is unusual for a Tibetan sword, judging by later Tibetan blades, which generally have a single edge. The norm for early Tibetan blades, however, has not been established. If not Tibetan, the blade found on this example may have been made for a *jian,* the classic double-edged straight sword favored by the Chinese nobility. DJL

45. Ceremonial Spearhead (*mdung rtse*)

Tibetan, 17th to 18th century
Iron, gold, and silver
L. 18¼ in. (46.4 cm)
Purchase, Arthur Ochs Sulzberger Gift, 2001
(2001.180)

This spearhead is notable for the quality and iconographic significance of its decoration. Its ceremonial nature is suggested by its unsharpened edges, blunt tip, and elaborate ornamentation. The stylized flames and flaming scrolls, damascened in gold and silver, are typical of the style and workmanship of motifs found on many examples of Tibetan ritual objects executed in decorated ironwork, such as the *rdo rje* (the diamond or thunderbolt symbol), *kha tvam ga* (tantric staff used in ritual contexts), and *spos phor rkang gsum ma* (incense-offering tripod). The most striking feature of the decoration, however, is the Tibetan lettering in the center of the blade. Done in the *dbu can* script, it can be read in two ways: either as *kyai,* a Sanskrit seed syllable sometimes associated with the protector deity Beg tse, or as *kye kye,* an invocation used in connection with requests for aid and protection. In either reading the characters demonstrate that this spearhead was intended for ceremonial purposes involving divine propitiation and possibly also as a votive object. It is therefore a key piece in explaining both the use of ceremonial Tibetan spearheads and the symbolic function of arms in traditional Tibetan society. DJL

46. Elements of a Ceremonial Horse Armor

Tibetan, mid-15th to early 17th century
Leather, steel, gold leaf, pigments, and textile
Left neck panel, h. 19½ in. (49.5 cm); right neck panel, h. 19¾ in. (50.2 cm); flancard, w. 24½ in. (61.5 cm)
Purchase, The Collection of Giovanni P. Morosini, presented by his daughter Giulia, by exchange; Bashford Dean Memorial Collection, Funds from various donors, by exchange; Fletcher Fund, by exchange, 1997 (1997.242a–c)

Ref.: LaRocca 1998, p. 79, ill.; LaRocca 1999b, pp. 118–20, fig. 11.

These three elements—right and left neck panels and a flanchard (protective flap suspended from the side of the saddle)—are the remains of the most elaborate and decorative horse armor known from Tibet. The use of heavily armored horses in Tibet dates from as early as the sixth century and continued into the early twentieth century. By that time, however, horse armor, along with most other forms of armor and weapons, was largely confined to ceremonial events, such as the Review at Trapchi (Tibetan *grwa phyir tsis bsher*), a cavalry procession of that was part of the month-long New Year celebrations formerly held annually in Lhasa, the Tibetan capital.

The armor is made of overlapping bands of stiff leather. The vivid decoration consists of repeating patterns of stylized lotus, peony, and other blossoms, which are made of stencil-cut and glazed gold leaf set against alternating reddish orange, black, and maroon grounds. Each neck guard is further elaborated by a pierced-steel filigree panel filled with a sinuous scroll pattern (*pa tra*). In the center of the flanchard a single row of polished steel lamellae recalls the martial origins of this ornate ceremonial armor. These pieces represent a high point in the use of leather armor, as well as leatherwork in general, in Tibet.

 DJL

47. Chanfron (Horse's Head Defense)

Tibetan, late 13th to mid-15th century
Steel, leather, and copper alloy
H. 21 in. (53.3 cm); w. 23 in. (58.4 cm)
Purchase, The Collection of Giovanni P.
Morosini, presented by his daughter Giulia, by
exchange; Bashford Dean Memorial Collection,
Funds from various donors, by exchange; Fletcher
Fund, by exchange, 1997 (1997.242d)

Like the preceding pieces (cat. no. 46), this chanfron represents a particular style of horse armor, which is known only from examples found in Tibet. It is made up of a sturdy but flexible base of leather, onto which small square steel plates have been laced by an intricate series of leather thongs. To this are added wedge-shaped plates, embossed with a chevron pattern, on the cheeks and a large one-piece plate in the center. The steel flap at the bottom, pierced with a scroll pattern, would hang down over the horse's snout. A matching flap is missing from the top. The applied bar with a leaflike finial, running down the center, is very similar to those found on some Tibetan arm defenses and shields (cat. nos. 42 and 43). In addition, the copper trim on the edges of the center plate is reminiscent of the trim sometimes applied to Tibetan helmets.

Although generally similar in form to some chanfrons found in India and others depicted in Islamic miniatures, the Tibetan type remained unknown in the West until the 1903–4 Younghusband Expedition, during which British troops were faced by armored Tibetan cavalry. Because the use of armor was such a novelty in the early twentieth century, and because Tibetan armor and weapons were replete with otherwise unknown types, they were eagerly collected by members of the expedition. Many examples were brought back to Great Britain at the conclusion of the campaign, among them a few rare chanfrons such as this one.

DJL

48. Set of Ceremonial Saddle Steels

Tibetan or Chinese, ca. 1400
Iron, gold, lapis lazuli, and turquoise
H. (as mounted) 9⅞ in. (25 cm)
Purchase, Gift of William H. Riggs, by exchange,
and Kenneth and Vivian Lam Gift, 1999
(1999.118)

Ref.: LaRocca 1999, pp. 76–77, ill.; Sacred
Symbols 1999, cat. no. 71.

Saddles were familiar and essential utilitarian items in Tibetan society. Beyond this, the quality of saddles and the extent of their ornament were important indicators of social position. Nearly all saddles had some form of decoration, depending on the means and status of their owners.

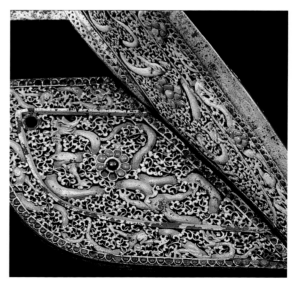

Fig. 16. Right rear saddle steel

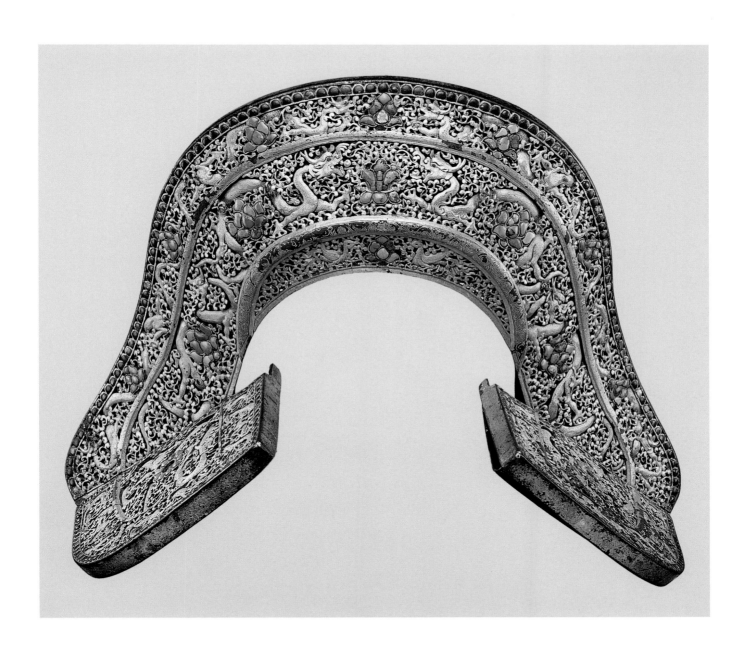

In addition to colorful textiles, this ornamentation usually included fittings in metal such as copper, silver, or iron. On more elaborate saddles all the exposed wooden areas of the saddle tree were covered with metal panels, known as saddle steels. This set of seven saddle steels is a superb example of Sino-Tibetan decorative ironwork. Each panel is delicately chiseled with a complex pattern of sinuously undulating dragons set amid filigree scrolls. The dragons and the scrolls were chiseled from the same relatively thick (5 mm) piece of iron, allowing the artist the depth necessary to interweave low and high relief throughout. In a virtuoso display of iron carving, the dragons are fully undercut, so that they are held by, yet are entirely separated from, the surrounding scrolls. The iron ground was minutely crosshatched in preparation for damascening in a thin layer of gold foil, which covers the entire surface. Interspersed among the dragons are lotus blossoms of polished turquoise. In the center of the pommel and cantle, dragons flank a flaming Precious Jewel (Tibetan *nor bu rin po che*), an important Buddhist symbol, also set in turquoise. The rich interplay of gold and turquoise is further enhanced by rows of lapis lazuli, which frame the outer edges of each panel. DJL

49. Helmet

*Chinese, possibly late Ming dynasty (1368–1644) or early Qing dynasty (1644–1911), ca. 17th century
Steel, gold, silver, and textile
H. 8¼ in. (21 cm)
Purchase, Bashford Dean Memorial Collection, Funds from various donors, by exchange, 1997 (1997.18)*

Ref.: LaRocca 1997, p. 90, ill.; LaRocca 1999b, pp. 114–15, 128–30, figs. 4, 33; Philip Tom 2002 (letter, Arms and Armor departmental files, Metropolitan Museum)

This helmet is distinctive both for the quality of its workmanship and for the lively character of its engraved and gilt

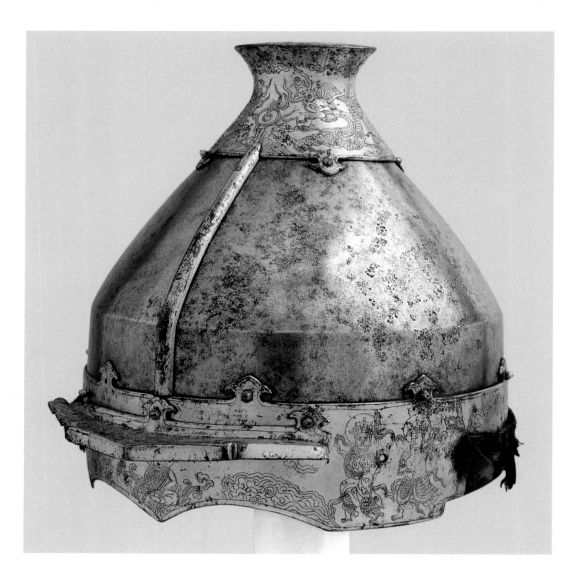

decoration. Because of its overall form and the style of its ornament, it appears to be an early example of helmet types that are usually associated either with the later part of the Ming dynasty (1368–1644) or the more familiar ceremonial helmets of the Qing dynasty (1644–1911).

The gilding of the fittings consists of two layers: silver foil burnished onto a crosshatched ground, over which a layer of gold was applied, probably by mercury gilding. This unusual two-stage technique gives the gilding its deep golden yellow luster. It also serves to highlight the crisply engraved ornament, which embellishes the helmet's finial, brim, and brow plate. In the center of the brow is the figure of Buddha Shakyamuni seated on a lotus throne. The Buddha is flanked by the four *lokapala,* the heavenly guardians of the four directions. Lively dragons, one on each side of a flaming pearl, appear on the finial and brim, a standard motif on virtually all later Chinese ceremonial helmets. Here, however, the design is rendered with a freshness and originality that are unknown on later, more stereo-typical examples. Therefore, the innovative nature of the decoration, combined with the skillful construction of the helmet, suggest that this is a very early example of its type. Like some other rare examples of Chinese art, its survival is apparently due to its preservation in Tibet, where it may have been sent from China during the Ming or Qing dynasties as a gift to a high-ranking secular or religious official.

DJL

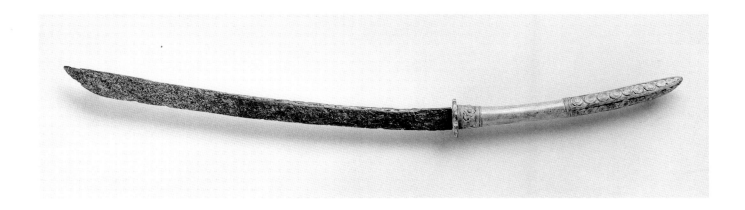

50. Short Sword

Southeast Asia, Dong Son period, ca. 5th to 2nd century B.C.
Bronze and iron
L. 24 in. (61 cm)
Rogers Fund, 2000 (2000.139)

The slender and elegant hilt of this short sword is a fine example of the advanced level of bronze-casting techniques present in Southeast Asia during the height of Dong Son culture. The repeating pattern of linked spiral motifs that decorate the hilt is found on other Dong Son bronzes and ceramics, but a sword hilt of this form and with these motifs is, up to this point, unprecedented. It is said to come from Thanh Hoa province in northern Vietnam, the region of the finds made in the 1920s and 1930s in the village of Dong Son, which first brought material of this type to the attention of Western archaeologists.

This type of sword appears to be indigenous only to that particular region of Southeast Asia. Swords with a very similar form of hilt, though not of bronze, and blades of this particular shape were still in use in Vietnam and were especially characteristic of Thailand as late as the nineteenth century. Therefore this short sword, in addition to being important as an example of early Southeast Asian bronze casting, demonstrates a previously unsuspected continuity of more than two thousand years for swords of this style.

DJL

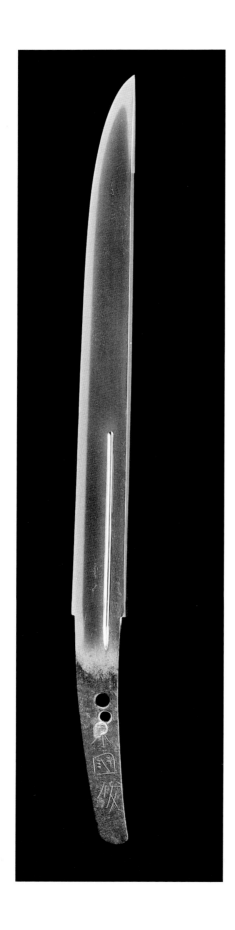

51. Blade for a *Tantō* (Dagger)

Kamakura period (1185–1333), ca. 1315–16
Steel
L. 9½ in (24.1 cm)
Inscribed: RAI KUNITOSHI
Gift of Mr. and Mrs. Robert Andrews Izard, 1991
(1991.373)

Ref.: Ogawa 1992, p. 89, ills.

The Rai school of swordsmiths, founded
by Kuniyuki in Kyōto, flourished from
the mid-thirteenth through the late four-
teenth century. One of the most famous
smiths of that school was Rai Kunitoshi,
whose dated works fall between 1290
and 1320. This *tantō,* among Kunitoshi's
finest, typifies the subtle artistry of his
work. The blade has the narrow, straight
shape Kunitoshi favored, a surface resem-
bling compact wood grain with a loose-
grained area near the tang, and an edge
tempered in a straight-line pattern.

The dating of this *tantō* is based on
the comparison of the second character
of his signature, *kuni,* with that found on
two signed and dated works by him. The
first is a *tachi* (slung sword) in the
Tokugawa Reimeikai Foundation, which
is dated October 13, 1315, when Kunitoshi
was seventy-five years old. The second
is a *tantō* in the Atsuta Shrine, which is
dated November 1316. Based on the evi-
dence of these two examples the Museum's
tantō should be dated to about 1315–16.
Once owned by the Tokugawa shoguns,
this *tantō* was later presented to a mem-
ber of the Arima family, the daimyos of
Kurume (present-day Kurume City in
Fukuoka prefecture) on Kyūshū.

MO

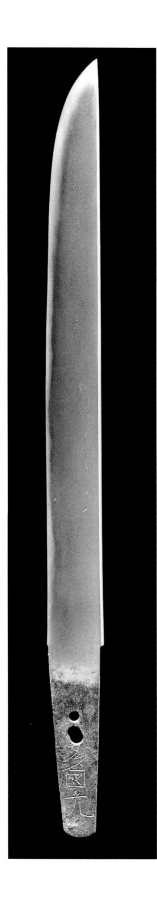

UDA KUNIMITSU
JAPANESE, ACTIVE EARLY TO
MID-14TH CENTURY

52. *Tantō* (Dagger)

Blade, Kamakura period (1185–1333), dated
November 1333
Steel
L. 16⅛ in. (40.9 cm)
Mountings, Edo period (1615–1868), 19th century
Silver copper, gold, shakudō, *ray skin, sharkskin,*
and wood
L. 17⅛ in. (44.8 cm)
Gift of Peter H. B. Frelinghuysen, 1998
(1998.127.2)

Ref.: Harada 2002, pp. 70–71, ill.

Uda Kunimitsu lived in Uda in Yamato
(present-day Nara prefecture) and later
moved to Ecchū (present-day Toyama
prefecture). He is recorded as working in
the early to mid-fourteenth century. There
were three generations of Kunimitsu
swordsmiths who were active from the
early fourteenth to the mid-fifteenth cen-
tury, spanning the late Kamakura period
to the mid-Muromachi period. Uda
Kunimitsu was the first-generation sword-
smith of the family and founder of the
Uda School. Although there are a small
number of surviving swords signed by Uda
Kunimitsu, until the authentication of
the inscription on this *tantō* in 1998 there
were no known works by him that were
both signed and dated. This *tantō*, there-
fore, provides an important foundation
for the study of the entire Uda School.

The shape of the *tantō* has a very slight
curvature, with proportions that are wider
and somewhat larger than a typical *tantō*
of the early fourteenth century, but which
became more common later in the cen-
tury. The surface texture of this blade
combines the appearance of a wood grain
with a straight grain. The edge is tempered
with a narrow straight line bordered
by a double line, characteristics that
show the influence of the Yamato School
of swordsmiths.

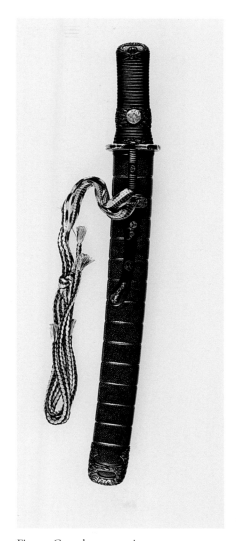

Fig. 17. Complete mountings

The unsigned mountings, which were
made for this *tantō* in the nineteenth
century, are subtle and elegant (fig. 17).
The ribbed scabbard is covered in black-
lacquered sharkskin. The metal fittings
on the hilt and the scabbard are made of
silver and are beautifully chiseled with
billowing waves. These are completed by
the *menuki* (grip buttons), which are gilt
copper, and the *tsuba* (sword guard),
which is *shakudō* (a copper and gold
alloy patinated bluish black) inlaid
with gold. MO

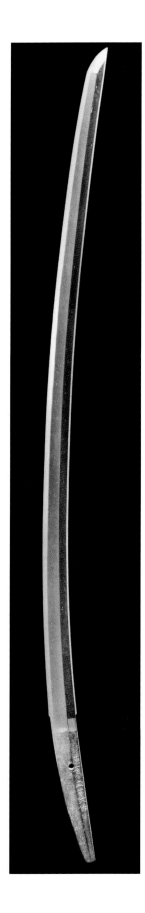

53. Blade for a *Katana* (Sword)

Muromachi period (1392–1573), dated 1526
Steel
L. 36⅛ in. (91.8 cm)
Purchase, Arthur Ochs Sulzberger Gift, 2001
(2001.574)

Ref.: Sato 1963, rubbing, n.p.; Sato 1969,
pp. 174–75, ills.; Tsuchiya n.d,, vol. 1, p. 218
rubbing.

Masazane was a swordsmith active in the late Muromachi period in Ise (in present-day Mie prefecture). He was one of the most important swordsmiths of the Sengo Muramasa School. His best-known work is a spear, the so-called Tonbogiri (dragonfly cutter), one of three famous spears, each of which was made by a renowned swordsmith.

This sword has a highly distinctive steel surface, made in the *ayasugihada* (concentrically curved grain) pattern. Blades with the *ayasugihada* pattern have been the trademark of the celebrated Gasan School of swordsmiths since the fourteenth century. This Masazane sword is the only known example of a blade with the *ayasugihada* pattern made by a swordsmith outside of the Gasan School. It is thus an important example of both the work of Masazane and the influence of the Gasan School on other swordsmiths. The sword is in perfect condition, is signed and dated, and has an extremely rare grain pattern, a combination of important qualities seldom found in a single sword. The tang is inscribed on the front, FUJIWARA MASAZANE SAKU (Masazane made this) (fig. 18), and on the reverse, DAIEI ROKUNEN HACHIGATSU JŪNINICHI (August 12, 1526).

MO

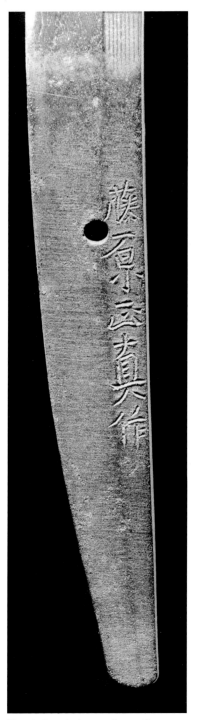

Fig. 18. Inscription on front of tang

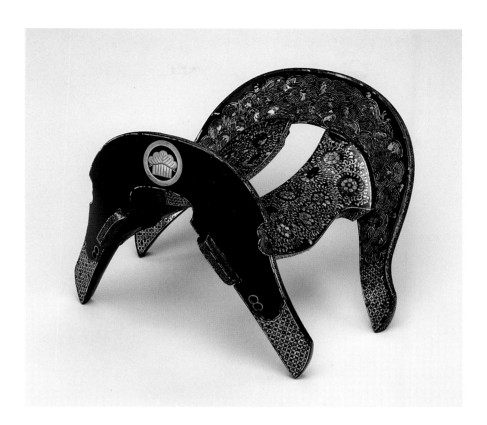

54. Saddle (*Kura*)

Japanese, Edo period (1615–1868), dated 1658
Wood, lacquer, abalone shell, and gold
L. 14½ in. (36.8 cm)
Purchase, Morihiro and Sumiko Ogawa Gift, in
memory of Dr. Sato Kanzan, 2000 (2000.405)

Ref.: Japanese and Korean Works of Art *2000,*
lot 188, ill.; LaRocca 2001, pp. 82–83, ill.

Japanese saddles are distinguished by an ingeniously simple method of construction combined with a virtually inexhaustible range of decorative motifs.

The construction usually consists of only four pieces of skillfully shaped wood, which are held together by mortise and tenon joints and fastened in place by hemp or leather lacing. The surfaces are covered in lacquer (*urushi*) and often incorporate designs in gold or silver and inlays of ivory, mother-of-pearl, or abalone shell. This saddle is a particularly fine example of black and gold lacquer with extensive abalone shell inlay. It is especially distinctive, as it is possibly the only example with inlay of this kind that is signed, dated, and made for a known

family. The underside is marked with the as yet unidentified *kao* (seal or monogram) of the saddle maker and with the date *Meireki yon sai* (equivalent to 1658). The outer faces of the pommel and cantle are decorated in gold with the *mon* (heraldic insignia) of the Nishio family, daimyo of Yokosuka (in present-day Shizuoka prefecture). Delicate inlay covers much of the saddle and features designs of billowing waves (*seikaiha*) and round blossoms set among lush scrolling vines (*karakusa*). D J L

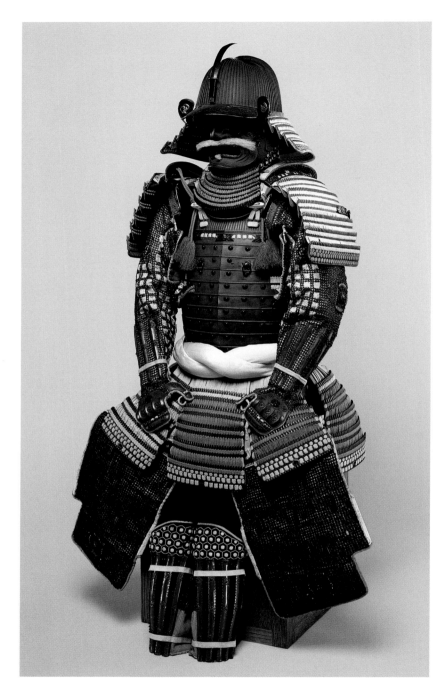

BAMEN TOMOTSUGU
JAPANESE, ACTIVE 18TH CENTURY

55. Armor of the *Gusoku* type

Edo period (1615–1868), 18th century
Lacquered iron and leather, shakudō, silver, silk,
horse hair, and ivory
H. as mounted, 58⅛ in. (148.8 cm); w. 18¾ in.
(47.6 cm)

Gift of Etsuko O. Morris and John H. Morris Jr.
in memory of Dr. Frederick M. Pederson, 2001
(2001.642)

Ex coll.: Frederick M. Pederson; Henry Iijima.
Ref.: Dunn 2001, p. 100, pl. 153.

The term *gusoku* or *tosei gusoku* is used to
describe a complete set of armor of the
form used in Japan from about the six-
teenth century to the nineteenth century.
It consists of a *dō* (torso defense), usually
constructed of hinged plates with fix-
tures on the back to support a banner
(*sashimono*) and with an attached *kusazuri*
(skirt) of seven or eight sections; a *kabuto*
(helmet), *hoate* (face mask), *sode* (shoul-
der guards), *kote* (hand and arm defenses),
haidate (thigh guards), and *suneate* (shin

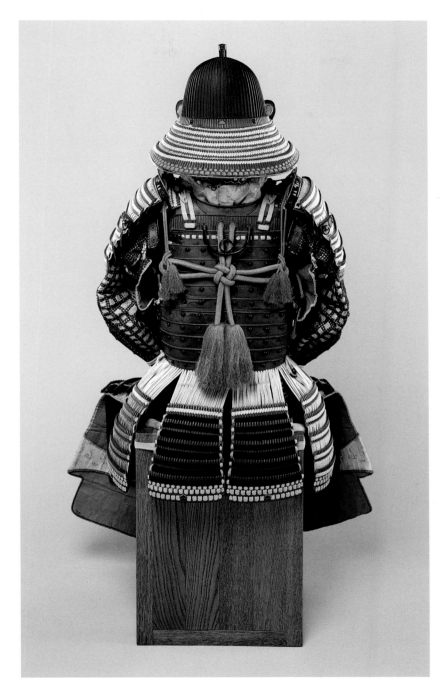

guards). This *gusoku* is remarkable for being complete, retaining all of its matching elements in an exceptional state of preservation, and for being a superb example of the armorer's art in Japan.

The *hachi* (helmet bowl), consisting of eighty-four ridged plates, is signed on the inside EICHIZEN NO KUNI TOYOHARA JŪ BAMEN TOMOTSUGUSAKU (made by Bamen Tomotsugu living in Eichizen province, Toyohara village). Bamen Tomotsugu was the leading armorer of the Bamen School in the eighteenth century. The iridescent black surfaces seen on the *dō* and other parts of the metal fittings are achieved by *gindami-nuri* (silver powder mixed with lacquer), a decorative technique that is rarely found on armor. In addition, the distinctive *odoshi* (silk lacing) on the skirt, in white, orange, green, and blue, is the only known example of a Japanese armor with this color scheme.

The *mon* (heraldic insignia) in the form of three whirling commas (*mitsudomoe mon*) is that of the Okabe family, feudal lords of Kishiwada (present-day Kishiwada City in Osaka prefecture). M O

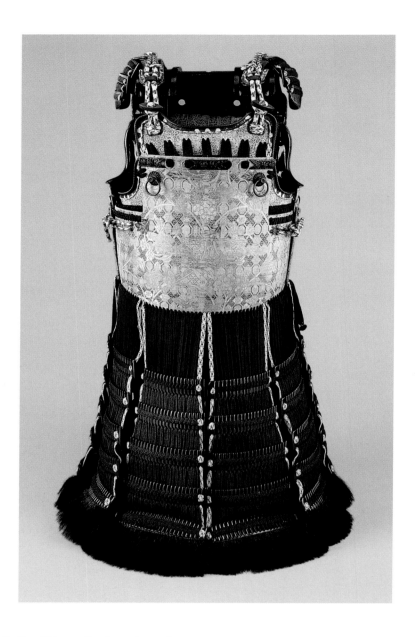

usually covered only with lacquer or plain leather, also has stenciled doeskin, another indication of its high quality. The fittings are made of *shakudō,* an alloy of copper and gold in which the finished surface is patinated a bluish black. They are finely chiseled with Paulownia blossoms and arabesques and are among the best examples of this type of metalwork. The *kusazuri* (skirt) consists of eight sections, the bottom edge of each being lushly trimmed with bear fur. The colorful *odoshi* (silk lacing) is equally an integral part of the armor's construction and its decoration. Very few armors of this form, quality, and condition have survived in Japan or anywhere else. MO

UJIYOSHI
JAPANESE, ACTIVE 18TH CENTURY

57. *Abumi* (Stirrups)

Edo period (1615–1868), 18th century
Iron and silver
H. 10 in. (25.4 cm); l. 11¼ in. (28.6 cm);
W. 5¼ in. (13.3 cm)
Gift of Estate of James Hazen Hyde, by exchange,
1997 (1997.194.1, .2)

The majority of Japanese stirrups are decorated only on their exterior surfaces, either in *urushi* (Japanese lacquer) or in inlaid iron. Stirrups in which the inlaid decoration covers both the interior and the exterior surfaces are extremely rare, there being perhaps less than a dozen pairs in existence. Inlaying the deepest recesses of the stirrup interiors would have been extremely difficult and demonstrates the great craftsmanship of their maker. The profuse designs of swelling waves and clouds that cover these stirrups were popular motifs in eighteenth-century Japanese works of art, such as paintings, sword fittings, and textiles. The waves on the stirrups are rendered with a realism and delicacy rivaling the artistry of their depiction in any

56. *Dō* (Torso Defense) in the *Nishiki Zutsumi Nimaidō* Style

Japanese, Edo period (1615–1868), 18th century
Iron, lacquered leather, silk and silk brocade,
bear fur, and shakudō
H. as mounted, 27½ in. (69.9 cm)
Purchase, Rogers Fund, by exchange, 1998
(1998.16)

The Japanese name for this type of armor, *nishiki zutsumi nimaidō,* refers to the materials with which it is decorated and to the form of its construction. The exterior of the breast and back are wrapped with an elaborate silk brocade (*nishiki zutsumi*). Its basic construction is made in two halves, which are joined by a hinge on the left side (*nimaidō*). In addition, it is highlighted by *somegawa* (ornately stenciled doeskin).

The breastplate and backplate of this remarkably well preserved *dō* are made of large iron plates, rather than the *kozane* (small overlapping scales) frequently found on Japanese armor. The interior, an area

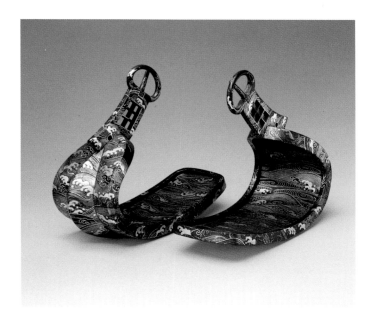

medium of the period. Both of these stirrups are signed by the artist, Ujiyoshi, who worked in Kanazawa (Ishikawa prefecture), which was known for the production of inlaid iron stirrups during the Edo period.　　　　　　　　　　　MO

58. *Sai Hai* (Signaling Baton) and Storage Box

Japanese, Edo period (1615–1868), 18th century
Sai hai: *wood, gold, lacquer, paper, and leather*
L. of shaft, 12⅛ in. (30.8 cm); l. of tassel, 12¼ in. (31.1 cm)
Box: *wood, lacquer, gold, silver, and silk*
16 x 8⅝ x 6 in. (40.6 x 21.9 x 15.2 cm)
Gift of Morihiro and Sumiko Ogawa, in memory of Bumpei Usui, 2000 (2000.324.1, .2)

This *sai hai* and its matching storage box are among the most finely made and best-preserved examples in existence. *Sai hai* were carried as signs of rank and used by military commanders to give the signal for an attack. The gold finials on this *sai hai* are beautifully engraved in the *kebori* technique (engraving in fine lines). The style of the engraving suggests an attribution to Yokoya Sōmin, one of the most famous makers of sword fittings in

the eighteenth century. The decoration of the finials features peony blossoms, which are the *mon* (heraldic insignia) of the powerful Tsugaru family, daimyos (lords) of Tsugaru (now in Aomori prefecture), who were also renowned as patrons of the arts. The use of heavy gold lacquer on the box lid and of solid gold finials on the shaft of the *sai hai* is very rare and indicates both the importance of these objects and the high status of their

owner. The choice of materials and the high level of craftsmanship also indicate clearly that they were made for the reigning lord of Tsugaru, rather than a junior member of the family. The Tsugaru continue to be one of the leading families in Japan, having been united in this generation to the imperial family through the marriage of Tsugaru Hanako and Prince Hitachi, the younger brother of the present emperor of Japan.　　　　　MO

WORKS CITED

Anonymous [Pratt] sale 1861
A Catalogue of the Collection of Ancient Armour, Weapons, and Antiquities Comprising Specimens from the Celebrated "Bernal," "De Peucker," and Dresden Collections. Sale cat. London: Sold by Charles Furber, 21 Old Bond Street, December 18–19, 1861.

Anonymous sale 1926
European Arms and Armor, mainly XV, XVI and XVII Centuries, including Artistic and Rare Specimens from Princely Provenance. New York: American Art Association, November 19–20, 1926.

Anonymous [Bartel] sale 1954
Catalogue of Arms and Armour including the Property of Colonel Sir Arthur Evans. Sale cat. London: Sotheby's, July 23, 1954.

Anonymous sale 1976
Highly Important Firearms: The Property of Mr. and Mrs. Luke Dillon-Mahon and from various sources. Sale cat. London: Christie, Manson & Woods, December 14, 1976.

Anonymous sale 1993
Waffenauktion: Bedeutende schweizerische Privatsammlungen. Lucerne: Galerie Fischer, June 17–18, 1993.

Allentown 1964
Stephen V. Granscay, ed. *Arms and Armor: A Loan Exhibition from the Collection of Stephen V. Granscay, with Important Contributions by the Metropolitan Museum of Art, New York, and the John Woodman Higgins Armory, Worcester, Massachusetts.* Exh. cat., Allentown Art Museum. Allentown, Pennsylvania, 1964.

Blackmore 1960
Howard L. Blackmore. "The Prince Regent as a Gun Collector." *Connoisseur,* December 1960, pp. 230–36.

Blackmore 1991
Howard L. Blackmore. "Neo-Classical Pistols." *Man at Arms* 13, no. 5 (September/October 1991), pp. 28–38.

Blair 1968
Claude Blair: *Pistols of the World.* London, 1968.

Campbell 1752
John Campbell, *A Full and Particular Description of the Highlands of Scotland,* London, 1752 (cited by Claude Blair, "A Type of Highland Target," in *Scottish Weapons and Fortifications 1100–1800,* ed. David H. Caldwell [Edinburgh, 1981], p. 391.

Demmin 1869
Auguste Demmin. *Guide des amateurs d'armes et armures anciennes par ordre chronologique depuis les temps le plus reculés jusqu'à nos jours.* Paris 1869.

Dunn 2001
Michael Dunn et al. *Traditional Japanese Design: Five Tastes.* Exh. cat., Japan Society. New York, 2001.

Écouen 1994
Les trésors du Grand Écuyer: Claude Gouffier, collectionneur et mécène à la Renaissance. Exh. cat., Musée National de la Renaissance. Château d'Oiron, Écouen. Paris, 1994.

Frost 1972
H. Gordon Frost. *Blades and Barrels: Six Centuries of Combination Weapons.* El Paso, Tex., 1972.

Goodhue sale 1992
Marine Paintings, Nautical Antiques, and American Furniture from the Marblehead Estate of Albert Goodhue, Jr. Sale cat. Manchester, New Hampshire: Northeast Auctions, Nov. 7, 1992, lot 71.

Grosjean sale 1993
Collection Albert Grosjean, armes et accessoires de chasse XVII–XVIII–XIXe siècle. Sale cat. Paris: Drouot Richelieu, October 18, 1993.

Gutowski 1997
Jacek Gutowski. *Tatar Arms and Armour.* Warsaw, 1997.

Harada 2002
Harada Kazutoshi. "Explanations of Sword Masterpieces," in *Project for Conservation of Works of Japanese Art in Foreign Collections.* Tokyo National Research Institute of Cultural Properties, 2002, pp. 69–91.

Hayward and Blair 1962
J. F. Hayward and Claude Blair. "The R. T. Gwynn Collections: Medieval Furniture, Armour and Early Clocks." *Connoisseur,* June 1962, pp. 78–91.

Hayward sale 1983
Arms and Armour from the Collection of the late J. F. Hayward. London: Sotheby Parke Bernet, November 1, 1983.

Hoopes 1940
Thomas T. Hoopes, "Loan Exhibition: Firearms of Princes." *Bulletin of the City Art Museum of St. Louis* 25, no. 1 (January 1940), pp. 10–15.

Houze 2002
Herbert G. Houze. "The True Origins of the 'American Style' of Firearms Decoration: A New Look at What Is Often Described as a Wholly American Style of Gun Engraving." *Man at Arms* 24, no. 1 (January/February 2002), pp. 22–27, 38–44.

Japanese and Korean Works of Art 2000
Japanese and Korean Works of Art. Sale cat. New York: Sotheby's, September 21, 2000.

LaRocca 1993
Donald J. LaRocca. "A Neapolitan Patron of Armor and Tapestry Identified." *Metropolitan Museum Journal* 28 (1993), pp. 85–102.

LaRocca 1993b
Donald J. LaRocca. In "Recent Acquisitions: A Selection, 1992–1993." *Metropolitan Museum of Art Bulletin* 51, no. 2 (Fall 1993).

LaRocca 1994
Donald J. LaRocca. In "Recent Acquisitions: A Selection, 1993–1994." *Metropolitan Museum of Art Bulletin* 52, no. 2 (Fall 1994).

LaRocca 1995
Donald J. LaRocca. In "Recent Acquisitions: A Selection, 1994–1995." *Metropolitan Museum of Art Bulletin* 53, no. 2 (Fall 1995).

LaRocca 1996
Donald J. LaRocca. *The Gods of War: Sacred Imagery and the Decoration of Arms and Armor.* Exh. cat., Metropolitan Museum of Art. New York, 1996.

LaRocca 1997
Donald J. LaRocca. In "Recent Acquisitions: A Selection, 1996–1997." *Metropolitan Museum of Art Bulletin* 55, no. 2 (Fall 1997).

LaRocca 1998
Donald J. LaRocca. In "Recent Acquisitions: A Selection, 1997–1998." *Metropolitan Museum of Art Bulletin* 56, no. 2 (Fall 1998).

LaRocca 1998b
Donald J. LaRocca. *The Academy of the Sword: Illustrated Fencing Books, 1500–1800.* Exh. cat., Metropolitan Museum of Art. New York, 1998.

LaRocca 1999
Donald J. LaRocca. In "Recent Acquisitions: A Selection, 1998–1999." *Metropolitan Museum of Art Bulletin* 57, no. 2 (Fall 1999).

LaRocca 1999b
Donald J. LaRocca. "An Approach to the Study of Arms and Armour in Tibet." *Royal Armouries Yearbook* 4 (1999), pp. 113–32.

LaRocca 2000

Donald J. LaRocca. In "Recent Acquisitions: A Selection, 1999–2000." *Metropolitan Museum of Art Bulletin* 58, no. 2 (Fall 2000).

LaRocca 2001

Donald J. LaRocca. In "Recent Acquisitions: A Selection, 2000–2001." *Metropolitan Museum of Art Bulletin* 59, no. 2 (Fall 2001).

Lavin 1997

James D. Lavin. *The Art and Tradition of the Zuloagas: Spanish Damascene from the Khalili Collection.* Exh. cat., Victoria and Albert Museum. London, 1997.

Leiden sale 1934

Waffensammlung Konsul A. D. Hans C. Leiden/Köln. Sale cat. Cologne: Math. Lempertz'sche Kunstversteigerung, June 19–21, 1934.

Lenk 1952

Torsten Lenk. "Nordiska Snapplåsvapen en Orientering." *Svenska Vapenhistoriska Sällskapets Skrifter,* n.s., 2 (1952), pp. 15–45.

London 1931

Catalogue of a Loan Exhibition of Scottish Art and Antiquities at 27, Grosvenor Square, London. London, 1931.

Mackay sale 1939

A Portion of the Famous Collection of Arms and Armour and Works of Art, the Property of the Late Clarence H. Mackay, Esq. Sale cat. London: Christie, Manson & Woods. July 27, 1939.

Milleker 2000

Elizabeth J. Milleker, ed. *The Year One: Art of the Ancient World East and West.* Exh. cat., Metropolitan Museum of Art. New York, 2000.

Müller-Hickler 1926

Hans Müller-Hickler. *Bezeichnung der Rüstungen und Waffen in dem Rittersaal Sr. Erlaucht des Grafen Konrad zu Erbach.* Erbach im Odenwald, 1926.

Neal 1966

W. Keith Neil. "Duelling Pistols." In *Antiques International: Collectors' Guide to Current Trends,* ed. P. Wilson, pp. 260–61. London 1966.

New York 1931

Stephen V. Grancsay. *Loan Exhibition of European Arms and Armor.* Exh. cat., Metropolitan Museum of Art. New York: 1931.

Ogawa 1992

Morihiro Ogawa. In "Recent Acquisitions: A Selection, 1991–1992." *Metropolitan Museum of Art Bulletin* 50, no. 2 (Fall 1992).

Pyhrr 1993

Stuart W. Pyhrr. In "Recent Acquisitions:

A Selection, 1992–1993." *Metropolitan Museum of Art Bulletin* 51, no. 2 (Fall 1993).

Pyhrr 1994

Stuart W. Pyhrr. In "Recent Acquisitions: A Selection, 1993–1994." *Metropolitan Museum of Art Bulletin* 52, no. 2 (Fall 1994).

Pyhrr 1995

Stuart W. Pyhrr. In "Recent Acquisitions: A Selection, 1994–1995." *Metropolitan Museum of Art Bulletin* 53, no. 2 (Fall 1995).

Pyhrr 1996

Stuart W. Pyhrr. In "Recent Acquisitions: A Selection, 1995–1996." *Metropolitan Museum of Art Bulletin* 54, no. 2 (Fall 1996).

Pyhrr 1998

Stuart W. Pyhrr. In "Recent Acquisitions: A Selection, 1997–1998." *Metropolitan Museum of Art Bulletin* 56, no. 2 (Fall 1999).

Pyhrr 1999

Stuart W. Pyhrr. In "Recent Acquisitions: A Selection, 1998–1999." *Metropolitan Museum of Art Bulletin* 57, no. 2 (Fall 1999).

Pyhrr 2000

Stuart W. Pyhrr. In "Recent Acquisitions: A Selection, 1999–2000." *Metropolitan Museum of Art Bulletin* 58, no. 2 (Fall 2000).

Pyhrr 2000b

Stuart W. Pyhrr. *European Helmets 1450–1700: Treasures from the Reserve Collection.* Exh. cat., Metropolitan Museum of Art. New York, 2000.

Pyhrr 2001

Stuart W. Pyhrr. In "Recent Acquisitions: A Selection, 2000–2001." *Metropolitan Museum of Art Bulletin* 59, no. 2 (Fall 2001).

Pyhrr and Godoy 1998

Stuart W. Pyhrr and José A. Godoy. *Heroic Armor of the Italian Renaissance: Filippo Negroli and His Contemporaries.* Exh. cat., Metropolitan Museum of Art. New York, 1998.

Renwick sale 1972

Catalogue of Highly Important Firearms from the Collection of William Goodwin Renwick (European, part I). London: Sotheby's, July 17, 1972.

Richardson 1996

Thom Richardson. "The Ming Sword." *Royal Armouries Yearbook* 1 (1996), pp. 95–99.

Rogers and LaRocca 1999

Hugh C. Rogers and Donald J. LaRocca.

"A New World Find of European Scale Armor." *Gladius* 19 (1999), pp. 221–30.

Sacred Symbols 1999

Robert A. F. Thurman and David Weldon, eds. *Sacred Symbols: The Ritual Art of Tibet.* Sotheby's and Rossi and Rossi. New York, 1999.

Sato 1963

Sato Kazan. *Iseno Tōkō.* Ōtsuka Kogeisha, Tokyo, 1963. N.p.

Sato 1969

Sato Kazan. *Kanzan Shoronbunshū,* Ōtsuka Kogeisha, Tokyo, 1969.

Southwick 2001

Leslie Southwick. *London Silver-hilted Swords, Their Makers, Suppliers and Allied Traders, with Directory.* Leeds, 2001.

Thomas 1965

Bruno Thomas. "Die münchner Harnisch-vorzeichnungen mit Rankendekor des Étienne Delaune." *Jahrbuch der Kunst-historischen Sammlungen in Wien* 61 (1965), pp. 41–90.

Tillou 1992

Firearms: A Catalogue of Distinguished Firearms from Peter Tillou Works of Art Ltd. London, 1992.

Tsuchiya n.d.

Tsuchiya Onchoku. *Tsuchiya Oshigata.* 2 vols. Chūō Tokenkai, Tokyo [early 19th century].

Wennberg 1982

Kåa Wennberg. *Svenska Gevärssmeder.* Stockholm, 1982.

Williamsburg 1977

Wallace B. Gusler and James D. Lavin. *Decorated Firearms, 1540–1870, from the Collection of Clay P. Bedford.* Exh. cat., The Colonial Williamsburg Foundation. Williamsburg, Virginia, 1977.

Wilson 1974

R. L. Wilson. *The Book of Colt Engraving.* North Hollywood, Calif., 1974.

Wilson 1979

R. L. Wilson. *The Colt Heritage: The Official History of Colt Firearms from 1836 to the Present.* New York, 1979.

Wilson 1995

R. L. Wilson. *Steel Canvas: The Art of American Arms.* New York, 1995.

Wilson 1997

R. L. Wilson, "The Sultan of Turkey's Famous Colt Dragoon Revolver, s/n 12406." *The Rampant Colt* 16, no. 1 (Spring 1997), pp. 4–8.

Wilson n.d

R. L. Wilson. *The Colt Engraving Book.* Vol. 1 (ca. 1832–1921). New York, n.d. [2000].

This publication is issued in conjunction with the exhibition "Arms and Armor: Notable Acquisitions 1991–2002" held at The Metropolitan Museum of Art from September 4, 2002, to June 29, 2003.

This publication is made possible by The Evelyn Sharp Foundation.

Published by The Metropolitan Museum of Art, New York

John P. O'Neill, Editor in Chief
Kathleen Howard, Editor
Robert Weisberg, Designer
Elisa Frohlich, Production
Photography by Oi-Cheong Lee, The Photography Studio,
The Metropolitan Museum of Art

Set in Trajan and Garamond
Color separations by Professional Graphics Inc., Rockville, Illinois
Printed by Brizzolis Arte en Gráficas, Madrid
Bound by Encuadernación Ramos, S.A., Madrid
Printing and binding coordinated by Ediciones El Viso, S.A., Madrid

Cover illustration: Portions of an Armor for Vincenzo Luigi di Capua, Prince of Riccia (cat. no. 13)
Frontispiece: Detail of Colt Third Model Dragoon Revolver (cat. no. 32)

Cataloguing-in-publication data is available from the Library of Congress.

ISBN: 1-58839-026-8 (The Metropolitan Museum of Art)
ISBN: 0-300-09876-6 (Yale University Press)